IMAGES
of America

IRVINGTON
FREMONT

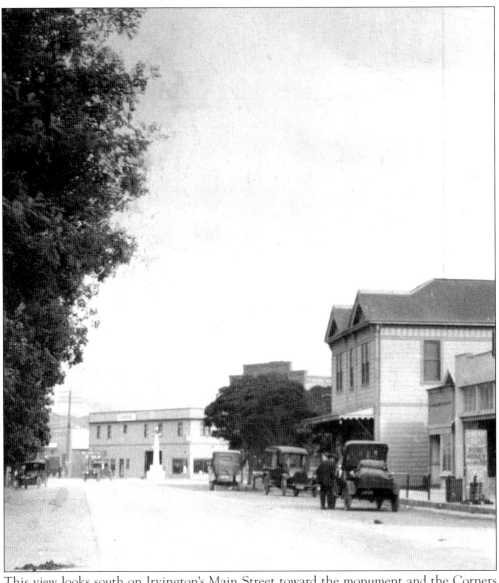

This view looks south on Irvington's Main Street toward the monument and the Corners building, around 1925. "The small group of people who arrived here in 1847 lived closely as a community unit, and may be considered to have been a village in the true sense of that word, two years before Mr. H. C. Smith's first store in the Mission. Irvington was first in industry, manufacturing, mechanics and grain warehouses—and that saloon on the 'Corners' was there before even Mr. Horner arrived." (From *History of Washington Township* by the Country Club of Washington Township, 1950.)

IMAGES
of America

IRVINGTON
FREMONT

Philip Holmes and Jill M. Singleton

Published by Arcadia Publishing
Charleston SC, Chicago IL, Portsmouth NH, San Francisco CA

Printed in Great Britain

Library of Congress Catalog Card Number: 2005929100

For all general information contact Arcadia Publishing at:
Telephone 843-853-2070
Fax 843-853-0044
E-mail sales@arcadiapublishing.com
For customer service and orders:
Toll-Free 1-888-313-2665

Visit us on the internet at http://www.arcadiapublishing.com

This book is dedicated to Dr. Robert B. Fisher.

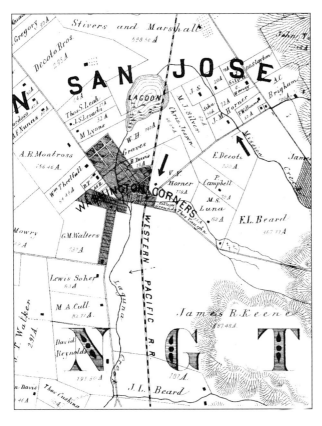

The Irvington area was mapped in the 1878 *Thompson and West Historical Atlas of Alameda County.* A century earlier, on March 31, 1776, Father Font noted in his expedition diary that Comandante Anza and his company traveled north from their camp on the Guadalupe River in the future Santa Clara County. The party camped in the Hayward area that night. The "higher ground at the foot of the hills" of their journey that day describes the Irvington area, where their route took a north-northwesterly direction. "After we had left the sloughs and taken the higher ground, we passed along the shores of a somewhat salty lagoon, which we left on our right and into which apparently flowed some arroyos from the canyons of the range of hills which we were following. All the rest of the road is through very level country, green and flower covered all the way."

CONTENTS

ACKNOWLEDGMENTS

We would like to thank our fellow board members and volunteers at the Museum of Local History in Fremont who helped this local work come together, including Barbara Baxter, Hugh Danaher, Regina Dennie, Andy MacRae, Sundaram Natarajan, Natalie Munn, and Gaylene Vincent. The authors benefited greatly by the dairy family research undertaken by board member Pat Wipfli Schaffarzyk, the detailed photograph descriptions by Alberta Nunes George, and Wes Hammond's wonderfully detailed *Memories of Irvington, 1933–1945*, published in 2004.

We would like to thank all those who gave us their time, support, pictures, and stories: Lila Bringhurst, Jim Chambers, Marvin Collins, John Connolly, Steve Connolly, Cheryl Cook-Kallio, Wayne Corrie, Robert Cunha, Dorsi Diaz, Don Dillon, Bernice Dutra, David Fisher, Jerry Fudenna, Kimie Fudenna, James Griffin, Dan Grimmer, Dr. Elmo M. Grimmer, Kurt Hammond, Mark Hirsch, Jackie Kearns, David Kiehn, Karen Kithcart, Nelson Kirk, Bernie Leal, Bruce McGregor, Becky McLain, Larry Milnes, Woody Minor, David Munn, Alberta Nunes, Ro Olivera, Ed and Debra Pentaleri, Jackie Phillips, Marilyn Price, Connie Rancadore, Dolores Rose, Cynthia Scott, James Sullinger, Velma Valencia, David Vodden, Earlene Walker, and many other friends of Irvington, past and present.

All photographs are part of the Museum of Local History Collections, including the Dr. Judge Haley Durham and the Dr. Robert B. Fisher Collections, Museum of Local History, unless otherwise credited. We would like to thank all those who contributed the use of their photographs, even though we were not able to use all of them; this book is testament to our appreciation. Thank you so much.

INTRODUCTION

Irvington is a crossroads, where the original mission road met routes leading to good landings on the sloughs that edge San Francisco Bay. All major transportation was water-oriented in the early years, so it is understandable that the first cluster of businesses was at the water's edge, where goods were unloaded at high tide. Washington Township had at least a half-dozen of these landings in use when it was formed in 1853. Crops could be loaded from them onto sloops, scows, and schooners bound for San Francisco or up the Sacramento River to sell at premium prices during the peak of the California gold rush. Origin Mowry brought his sloop *Neptune* here in 1848 and proceeded to do just that. His landing became known as Mowry's Landing, the closest one to the future town of Irvington.

In 1847, John Horner established an extraordinarily productive farm on the rich soils of Mission Creek, gently sloping down towards the great tule ponds and lagoons of what is now Central Park. He was celebrated as "California's first farmer." By 1852, he had brought out his extended family, established his own blacksmith and wheelwright shops, invented form machinery, and begun surveying and subdividing his lands. The surveying led to more roads at the junction, and the intersection became a five-pointed star.

In 1860, William Mack moved his store from Mowry's Landing up to the corner of Washington and Union Streets, across from the Corners Saloon, and the very successful blacksmith and wheelwright businesses of Crowell and Rix. Washington Public School opened in 1862, a sure sign of a growing population. The first Western Pacific Railroad was built from San Jose to Niles Canyon just three years later, stopping at Washington Corners. Yet, until 1870, the place was so small and the farms were so spread out that it was included in the federal census under Centerville.

Nonetheless, the farms and businesses in the area prospered, so when the suggestion was made in 1871 that they establish their own college, financing and a site came together immediately. The well-known faculty of a seminary near Oakland sought to relocate, and by July of 1872 the Washington College of Science and Industry was open, preparing hundreds of boys and girls for entrance into the newly opened state university.

The public school expanded, rebuilding on Union Street in 1875, the same year the first newspaper took up the task of reporting for the entire township and its "Base Ball matches." Great warehouses rose near the train depot along with a fine-flouring mill. A winery and vineyards began at Washington Corners in 1881, at that time the largest operation of its kind in California.

When the town changed its name to Irvington in 1884, it had meeting halls, its own full-time dentist and doctor, and literary and dramatic societies. Motorcars arrived and the first garage in the area was built at Irvington in 1906. By 1917, the traffic had become so great that the county contracted to have a lighted pillar built in the middle of the five-way intersection. Many of the dry-farmed fields of wheat became orchards or dairies. After the Hetch Hetchy pipeline and other water sources became more available, irrigated crops such as cucumbers, strawberries, and tomatoes became more common.

In 1939, the Irvington School District merged with Mowry Landing; followed by a merger in 1959 with Mission San Jose. Three new high schools were built over the next six years. In 1964, the Fremont Unified School District was formed and Irvington Grammar School became its

headquarters. Irvington grew so much that it attracted some of the earliest shopping centers in Washington Township, as well as the excitement of a drag-racing strip, a glider port, and the latest in bowling lanes.

A new city of Fremont, named by Irvington pharmacist Wally Pond, formed in 1956 and Irvington became one of the five towns that consolidated to create it. In the first General Plan, the farmlands and tule ponds of north Irvington were designated as the first civic center and the much-loved Central Park. Irvington also has Fremont's oldest park, Irvington Plaza, which is home to its great old flagpole and well-worn Irvington Monument that still magnanimously declares, "Irvington Welcomes You."

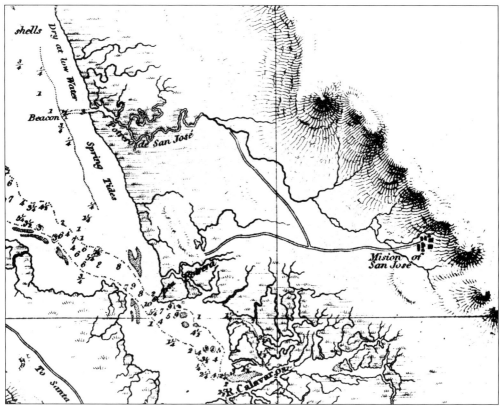

Capt. Frederick William Beechey of HMS *Blossom* mapped the trails to Mission San Jose from two landings on San Francisco Bay as part of a two-month survey of San Francisco Bay and Alta California. It was the last months of 1826, just after his explorations in Russian Alaska for the British Admiralty. The corn, wheat, peas, beans, and barley grown on the mission lands produced more than Mission San Jose needed for its own use; Fort Ross was their main customer until the early 1830s.

One

WAVES OF GRAIN
1847–1946

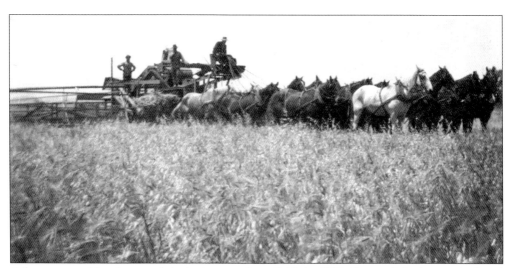

A harvest combine is at work in Irvington wheat fields in 1898. Some of the best agricultural production in the new State of California was on the Horner lands near Mission Creek. The book *California Agriculture* stated, "California was prominent in wheat production . . . together with the rapid development of farm machinery, favored large-scale production; by 1889 the State ranked second for wheat." (University of California Press, 1946.)

Among the earliest structures in Mowry Landing was the Mowry Landing School, pictured at left, and some of its earliest pioneers were the McDavid family. John McDavid and Origin Mowry built the schoolhouse about 1854, when the district was formed. A new school was built in 1874 that was itself replaced a decade later. That Mowry Landing School was used until the students transferred to the new Irvington School in 1939.

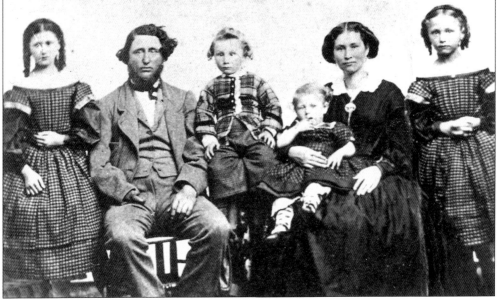

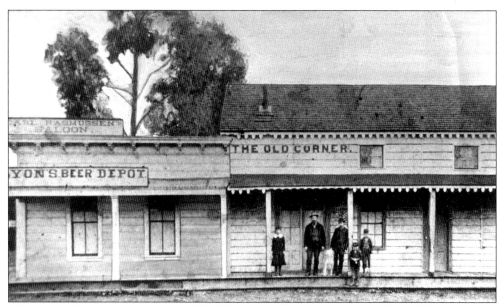

The Rasmussen family stands in front of their Old Corner Saloon with their dog Jack. There had been a saloon at the corner of the San Jose road and the Mission road since the 1850s. This picture was taken in 1882, when the town was still called Washington Corners. Pictured, from left to right, are Kate, Carl, Jack, unidentified, Chris, and William Rasmussen. The Old Corner Saloon was torn down for the Corner Garage around World War I.

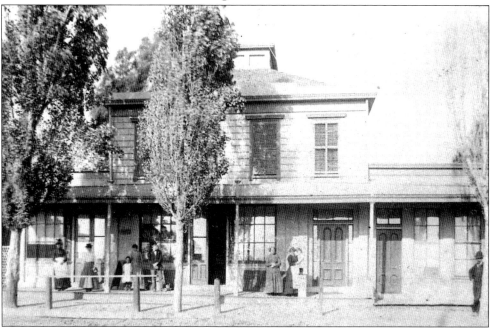

Mr. and Mrs. Mack built the first two-story building in Washington Corners around 1870 and ran their shop in the front portion. Mr. Mack was the first station agent and the second postmaster, though, according to the newspaper, it was Mrs. Mack's smiling face one was likely to see when being served at the counter. The first Mack store in 1860 was a tiny redwood building at the corner of Union and Centerville Roads.

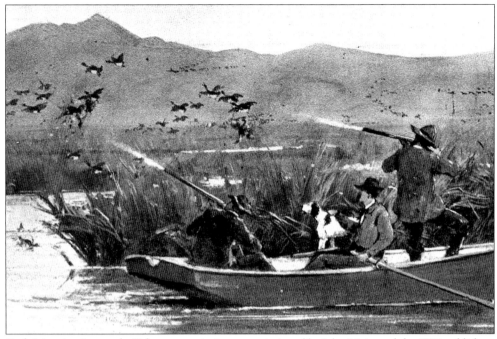

Early Morning Among the Tules was a painting commissioned by John Muir, and the 1894 publishers of the pictorial series titled *Picturesque California*. It was painted by Thomas Hill (1829–1908). Hill depicted the sloughs and lagoon just north of Irvington, now part of Central Park. In 1883, Francis Marion Smith of Oakland, the founder of 20 Mule Team Borax, leased this tule pond for several years as "a great resort for hunters."

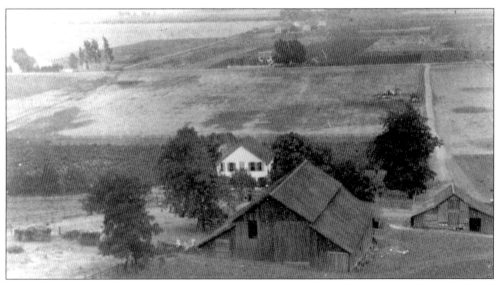

This is the Horner farmland as seen from the Slayton farm in the 1870s. John Miers Horner and his bride, Elizabeth Imlay, left New York the day after their wedding in 1846 and sailed to California. He was 25 and she 20 years old. They settled on Mission Creek in a rough cabin where their son William was born. A large adobe near their home, likely a granary for wheat, was lived in by farmhands from Chile in the early years.

In 1905, John Horner (1822–1907) wrote about his determination to be the best baseball player in New Jersey in the 1840s. In 1845, the Knickerbocker Club of New York made their historic baseball forays to the Elysian Fields in Hoboken, New Jersey. In 1847, Horner displayed that same competitive spirit when he invented some of the first large-scale farm machinery in California.

In 1847, John and Elizabeth Horner were the first Americans to settle the area, choosing the best farmland. William Yates Horner joined his brother in 1850, and by 1852, their extended family had joined them. Prefabricated houses were brought by sea from New England and across the bay to Mowry Landing. The Horners soon had enough players for their own baseball games—nine.

THE AUTHOR AT 31 YEARS OF AGE.

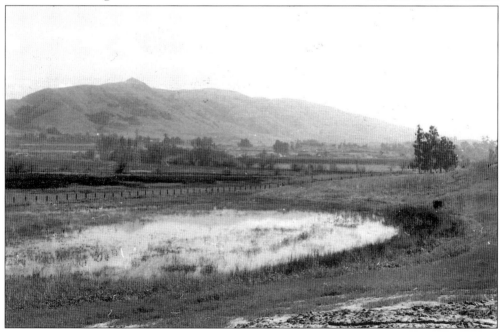

The home of Alfred Osgood Rix and his wife, Angie McDavid Rix (at left), on the Centerville road was photographed in the early 1880s. In 1882, the couple hosted a lunch for members attending events at the nearby Washington Lodge of the International Order of the Good Templars. "The company disposed themselves in inviting places under the trees, and on the broad shaded porch surrounding the house . . . Would you know the most delicious dish of all, the one most eagerly called for, and most perseveringly eaten? It was chicken pie; and such chicken pie! The crust delicately browned, rich, tender, and the savory contents! Ah!—but, we will not excite the envy of those unfortunates who were not there, by dwelling on its excellence. That lunch will be long remembered."

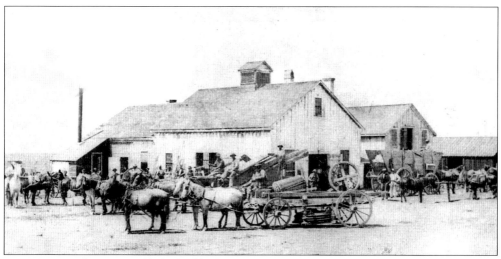

In 1853, Timothy Rix established a blacksmith shop at Washington Corners, shown above in an 1868 *carte de visite* (CdV) photograph. The location is just north of the brick International Order of Oddfellows (IOOF) building that was constructed in 1890.

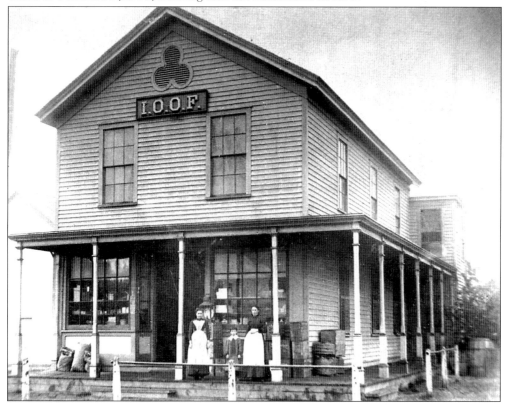

Caroline Hirsch stands on the porch of her store in 1896. The first Joseph Hirsch store opened at Washington Corners in 1867, and when Joseph died in 1887, he left it to his much younger wife and three teenage sons to carry on the business. William, Otto, and Alfred completed their schooling at Washington College before expanding the business in several directions in the new century.

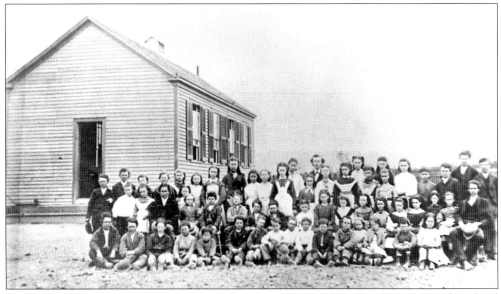

Irvington Grammar School pupils pose with their teacher in 1891. Family names at the school that year included Blacow, Cash, Chadbourne, Copeland, Cromot, Cronin, Decoto, Davies, Devilla, Enos, Gammon, Hirsch, Jessen, King, Levada, Lewis, Lowrie, Meyers, Nunes, O'Malley, Perry, Powell, Ramsell, Rasmussen, Seeber, Vandervoort, Vierra and Wamsley. The majority of families were immigrants from Europe.

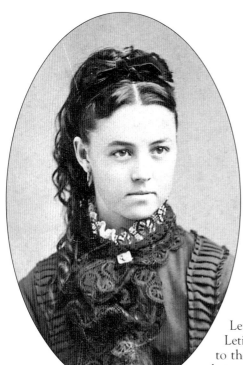

Letitia "Tish" Stivers was named for her great-aunt Letitia Marshall. The Marshalls had the adjacent farm to the north of the Stivers. Tish may have had this photograph made when she was a teenager in the 1870s, to give her friends in the days before yearbooks.

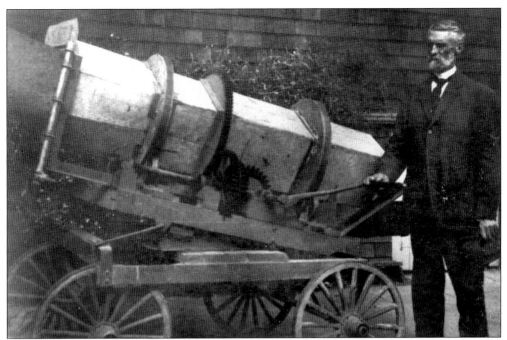

A. O. Rix stands to the side of his popular mechanical almond huller. Washington Corners in the late 1800s was a sea of almond blossoms in the spring. The Rix family was able to move their original prefabricated house of 1852 back (still standing on Bay Street) and build a grander two-story Italianate house on the Centerville road, complete with shady fig trees, a green lawn, a conservatory, and a croquet ground.

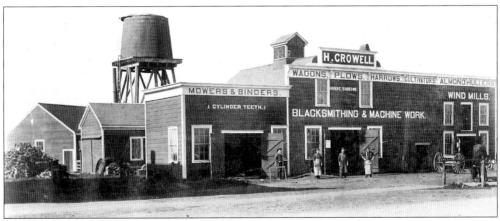

Blacksmith Herman Crowell moved to Washington Corners in 1861 and went into blacksmithing and machine work that included fabricating harvesting equipment and other mechanical inventions of John M. Horner as well as his own design for cylinder teeth on the harvester cutting bar. Crowell's two-story Italianate house was the largest in town, relocated to face Union Street on the back of the same lot when the Leal Theater was built in 1922.

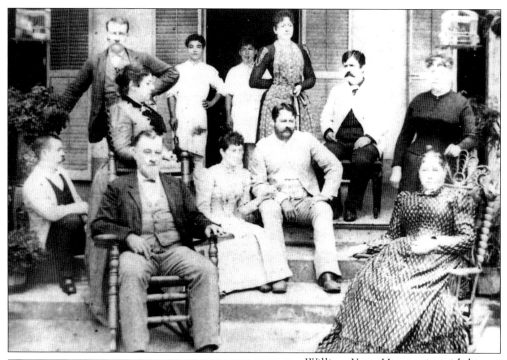

William Yates Horner sits with his family in front of their house. A September 1875 newspaper reported, "A match game of Base Ball was played at Alviso on September 12th, between the 'Rising Stars' of that town and the Good Templars of Washington, the latter being victorious." The Good Templars lineup included H. Blacow (left field), O. Benbow (right field), F. Horner (catcher), G. Horner (third base), C. Blacow (shortstop), F. Horner (first base), C. Freer (pitcher), W. Y. Horner (center field), and J. F. Coffaney (second base).

This 1868 advertisement in a San Francisco newspaper declares that the efficient design of the new harvester invented by John Horner will be demonstrated at Threlfall's model farm at Livermore and at Horner's own farm near Washington Corners and Mission San Jose. In 1879, the Horner families relocated to manage sugarcane estates in Hawaii, subdividing and selling their lands near Washington Corners.

NOTICE!

There will be a Public Exhibition of the

Traveling Harvester,

MONITOR NO. 2

Upon the farm of RICHARD THRELFALL, in Livermo Valley, Murray Township, Alameda County, on

Thursday, August 28, 1868,

Commencing at 1 o'clock P. M.

☞ On Thursday, the 3d day of September, commenci at the same hour, MONITOR No. 1 or 3 will be exhibited he public upon the farm cf WM. Y. HORNER, near t Mission San Jose, Alameda County.

We claim that one-half of the expense of harvesting wou be saved to the Farmer by using the Harvester; in fact, t entire expense of Threshing is saved.

Three men and twelve horses have Cut Threshed, Clean and Sacked, in good workmanlike manner, fifteen (15) acr of grain per day—making five acres per man—a feat, we b lieve, never performed in America before! One and thre quarter (1¾) acres to the man, working with the most a proved machinery, is about the highest figure yet reached one acre per man being nearer the general average.

☞ Farmers! come and see if our claims are w founded. JOHN M. HORNER, v80-5 WM. Y. HORNER.

The restored W. Y. Horner house still stands on Driscoll Road and is also called the Bond house or Bond-Horner house, as winemaker Bond lived here after the Horners. W. Y. Horner had formed the Irvington chapter of the Good Templars in 1870. When Clark Hall was built in 1876, the Good Templars leased the upper floor for their meeting place when they were not playing baseball.

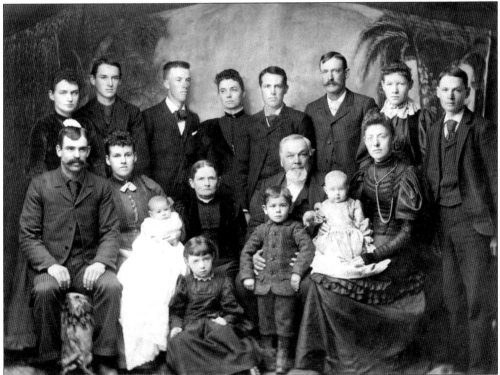

The Stivers family, seen here in the 1880s, farmed hundreds of acres to the east and north of what is now Central Park. Pictured, from left to right, are (first row) Ernest Millard (in christening robes), Grace Stivers (girl with bare foot), Ralph Millard, and baby Lillian Stivers; (second row) Joseph Millard, Charlotte Stivers Millard, Anna M. Jones Stivers, Simeon Stivers, and Lillian McCarthy Stivers; (third row) Edward Stivers, Champion Dorsey Stivers, Latisha Stivers, Samuel Stivers, Simeon Stivers, Eliza McCarthy Stivers, and Mark Stivers.

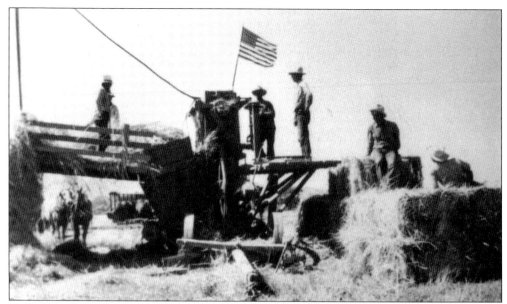

A flag was flown on top of the hay baler to indicate the wind direction so chaff spinning out of the machine blew away from the workers, rather than into their faces or into the hot, working parts of the machinery. In the 1930s, the baler was owned and operated by Bud and Clarence Telles. (Courtesy Velma Valencia.)

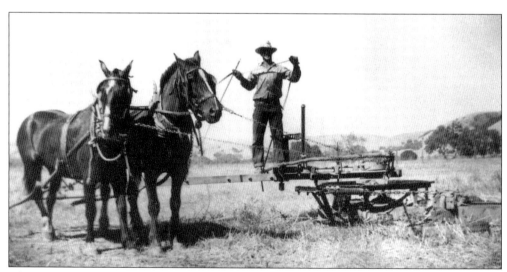

This horse-powered hay press was run by Clarence Telles in 1939. Leland Cutler remembers, "School was more or less adjusted to work on the farm. . . . As I grew older, I plowed and cultivated and pitched hay . . . I drove the horse that went around in a circle all day hitched up to a hay baler. I sewed sacks on a harvester rig one vacation at $1.75 per day. The day began at daylight and ended at darkness. We ate in a cook wagon and slept under the stars." (Courtesy Velma Valencia.)

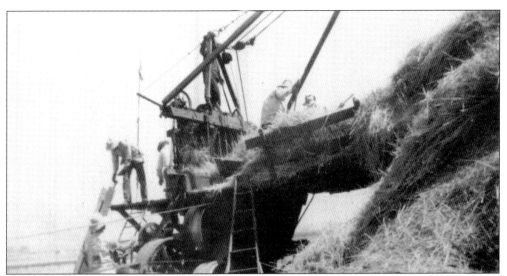

This photograph shows a *c.* 1945 vertical box-style press that used fine wires to tie the bales. It took a crew of eight to operate the baler. (Courtesy Velma Valencia.)

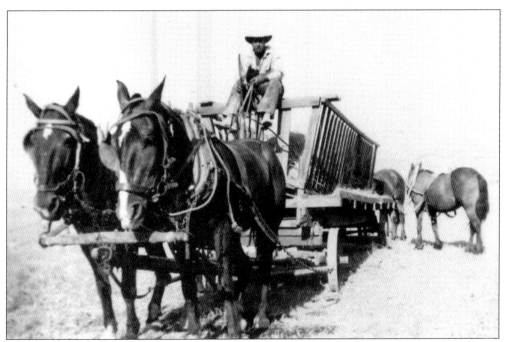

This *c.* 1937 photograph shows the wagon used to feed the horses during rest periods. Getting the hay off the fields and onto the wagon was the last part of the field assembly line. Once farming became less dependent on horses, the need for land dedicated to horses—to provide hay for bedding and grain for feed—decreased. By 1900, mixed farming increased around Irvington. Fruit and nut orchards, dairy, poultry, and field crops became popular as they had a greater return per acre. (Courtesy Velma Valencia.)

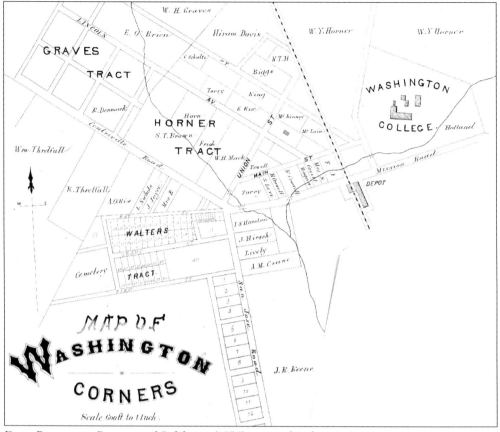

Dana Pearson, in *Resources of California* (1876), wrote this description:

> Washington Corners is a pretty village, of 300 or 400 people, in a very rich grain growing
> section of our valley, four miles south of Niles, on the railroad; it contains three hotels
> and boarding houses, three stores, one livery stable, one Drug Store, one large carriage,
> wagon and blacksmith shop, that of Crowell and Rix, who do an extensive business with
> a branch shop in Livermore; also, one large warehouse, one shoe shop, one meat market,
> Lodges of I.O.O.F. and I.O.G.T., an excellent public school employing two teachers at
> salaries of $100 and $50; an able weekly the Alameda County Independent, edited and
> published by W.W. Theobalds; and last but not least, Washington College.

When Rev. S. S. Harmon and Mrs. F. W. Harmon closed their seminary in Oakland, they brought
a ready-made student clientele with them to Washington College, on the top right of this map. In
1864, when Mark Twain worked for a year at the San Francisco *Daily Morning Call*, he reviewed
the Mechanics Institute Industrial Fair held in September of that year and noted the following
visitors at the fair: "This detachment of [70] young ladies was from Mrs. Harmon's Pacific Female
Seminary, one of the best schools in the State."

Two

COLLEGE TOWN
1871–1914

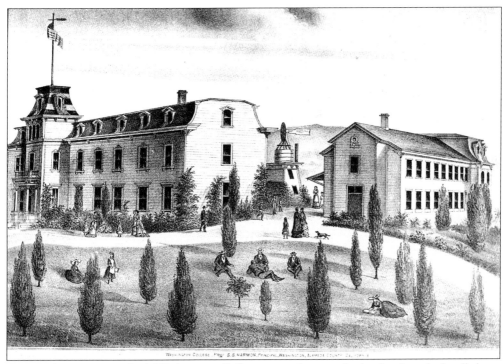

In 1871, the community built Washington College, a co-ed, private high school on the knoll above town on land donated by Elias Beard. Two of the Harmon daughters taught at the school, and one of them later married Professor Edward Wickson of Berkeley, who was the brother of fellow teacher Miss E. J. Wickson. The Harmons retired in 1881 when their youngest son graduated.

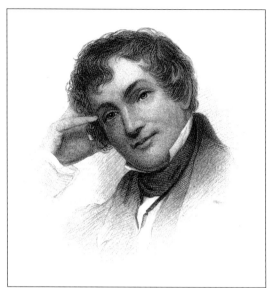

This is a portrait of author Washington Irving (1783–1859) as a young man, the first internationally acclaimed American author. His name became attractive to small American towns that took pride in education. Rev. James McCullough was an alumnus of Butler College in Irvington, Indiana, and he apparently influenced a name change for Washington Corners by misaddressing his mail. By 1887, the name Irvington was the name of record. The name Washington survived with the Washington School District until 1912, and at Washington College until 1894. Washington Boulevard was named after Fremont incorporated in 1956.

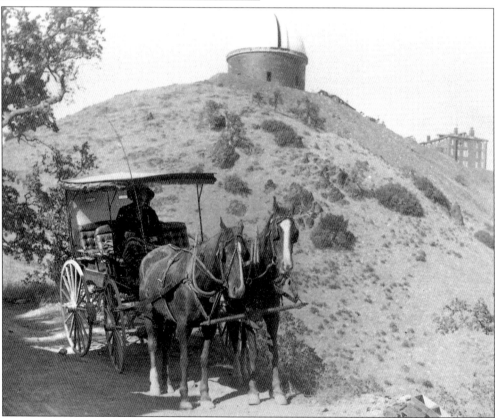

Lick Observatory on Mount Hamilton, a day's carriage ride to the southeast, sometimes lent visiting professors for Washington College, beginning in the early 1880s. The *San Francisco Bulletin* described Washington College on May 27, 1886, "The curriculum at present embraces preparatory, scientific, classical and commercial courses. . . . The climate of the location is healthful, the corps of teachers efficient and the discipline rigidly enforced."

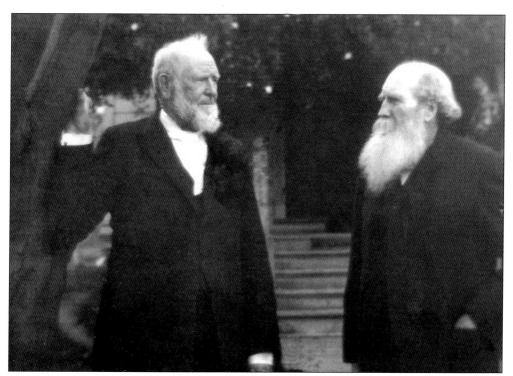

Rev. James McCullough and his brother stand for this photograph in their later years. Between 1883 and 1894, Washington College was sponsored by the Christian Church, a reform church with origins in Scots-Irish immigration to the United States, and supporter of co-ed, advanced education in the latter 19th century. Professor Rev. J. D. Durham was appointed president of the college in 1889.

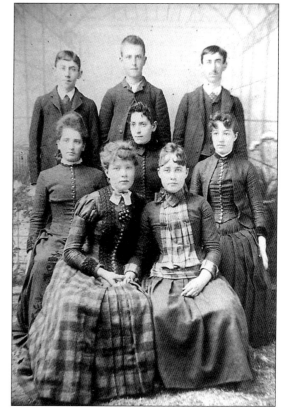

Several of these graduates of Washington Public School entered Washington College in 1884. Pictured here, from left to right, are (first row) two unidentified women; (second row) unidentified, Miss Reynolds (the teacher) and Minnie Slayton; (third row) Otto Hirsch, Clay Brewer, and Alfred Hirsch. Both the Hirsch boys completed the commercial course and were also in demand for baseball matches, with Otto as catcher and Alfred as pitcher, receiving up to $25 a game.

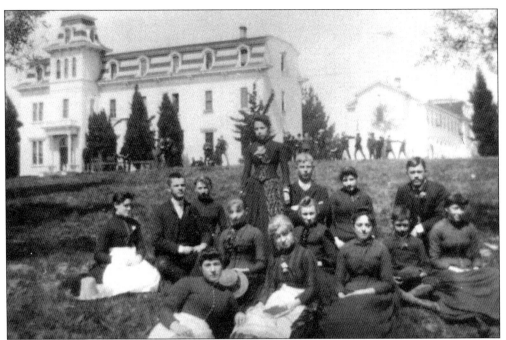

Washington College students are seen here in the late 1880s, with young Judge Haley Durham in the middle of the back row. He preferred to be called Haley at this stage of his life. His older sister Mary (next to him) completed a degree in music at Boston Conservatory of Music and came back to teach music at the college. Scientific boxing demonstrations can be seen in the background.

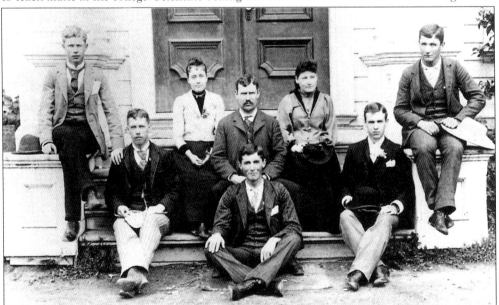

Judge Haley Durham is sitting on the left stoop of the college porch and William Alonzo Chance is on the bottom right in this 1891 commencement class photograph. All students took a similar curriculum in mathematics, history, geography, and English, as in public high schools, with electives in music, art, elocution, and telegraphy. The school year began the first week of August and ended the third week of May.

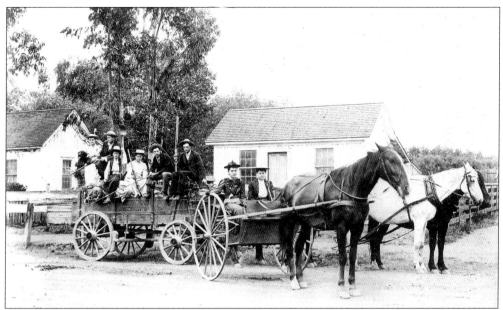

This group is dressed up for a picnic trip to the tules in 1894 and brought along their duck-hunting rifles. The party of picnickers in the spring wagon include, from left to right, Jennie Dixon, Dan Crosby, Mila Rix, Edith Johnson, Ezra Decoto, and Matt Dixon. Julia Rix and Helen Rix are in the two-wheel horse cart. Miss Dixon later married Daniel Crosby, one of the three Crosby boys, local athletes who were later well known in their professional careers.

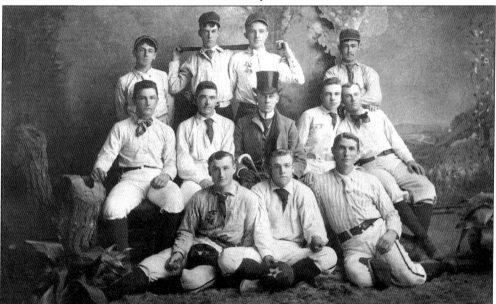

The baseball nine for Washington College was photographed in 1894. The team captain was George C. Whitman, J. Haley Durham's cousin from the Cameron, Illinois branch of the family (in his top hat, cane, and gloves). Frank L. Chance (at the lower right front) became player-manager of the Chicago Cubs in 1905. He was the first Californian elected to the National Baseball Hall of Fame for his success in leading the Cubs to several pennants and World Series championships. (Photograph by L. Stein.)

Curtner Seminary opened in 1895, when the last co-ed class graduated from Washington College. The Christian Church returned responsibility for the college to Mr. Henry Curtner and he hired the Ingrams from the former faculty to run the Curtner Seminary for Young Ladies. Mary Durham continued as the music specialist. Her widowed sister, Mrs. Cutler, joined the faculty as the art teacher and stated, "The College Home occupied by the young ladies is a handsome edifice, three stories high (including the Mansard roof), and will accommodate fifty-two pupils. It is substantially built; the rooms commodious and well ventilated; the furniture neat and suitable; and the appointments of the school and recitation rooms of the best character." (Gladys Williamson in the *Oakland Tribune*, April 15, 1953.)

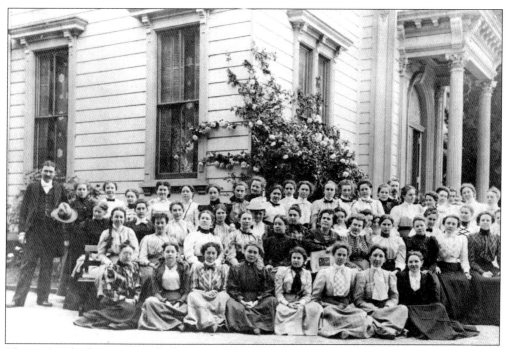

The student body poses outside the main college building with Mr. H. C. and Mrs. Ingar Ingram. While a high-school curriculum was initially offered, the school's strength was its normal course, where young women were trained to become teachers in the rapidly growing public-school system, particularly with all the high schools being established throughout the state.

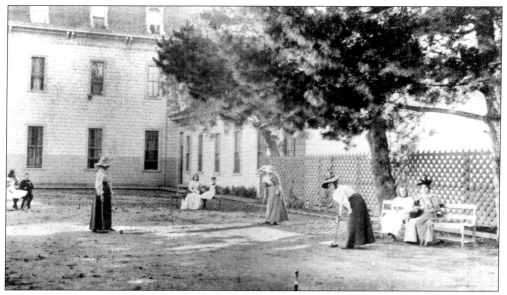

"This was the era of flowing skirts on croquet and tennis courts; voluminous sleeves and hats of the flopping brim variety adorned with flowers and velvet streamers; shirtwaist outfits stiff-brimmed sailors; gym suits with enough material to supply nearly a whole wardrobe for a modern co-ed. All this was proper attire for young ladies wielding Indian clubs on the Curtner Seminary campus." (Gladys Williamson in the *Oakland Tribune*, April 15 1953.)

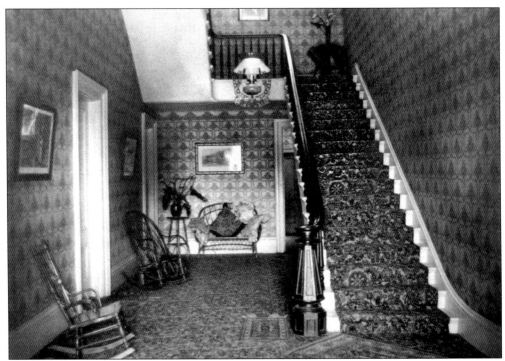

The interior of the main college building during the Curtner Seminary era had patterned wallpaper and carpets, gas lighting, and bamboo and bentwood furniture. It also had many framed pictures of classical scenes, with frames angled downward to avoid dust and fly specks.

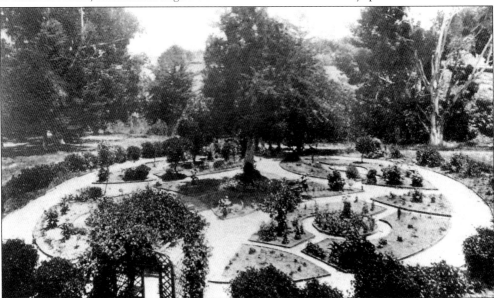

An elaborate parterre of garden beds was laid out between the college buildings, viewed best from the upper-story bedrooms of students or the giant water tower. The college had indoor plumbing and plenty of water, and the college creek also ran through the grounds. The garden was made with finely crushed gravel and notched boards bent into curves, creating elaborate planting-bed shapes.

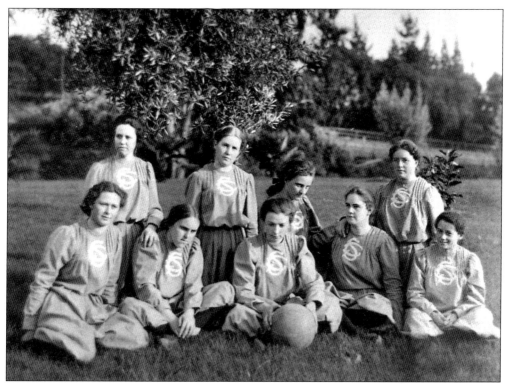

The Curtner Seminary basketball team poses here in 1896, with the "CS" insignia on their uniforms with bloomers. Basketball was invented by Canadian James Naismith while he was running programs at the YMCA. Originally it was a passing game, and dribbling was not standard play until a decade later. The game spread quickly to both men's and women's colleges, aided by catalogs selling specialized sporting goods.

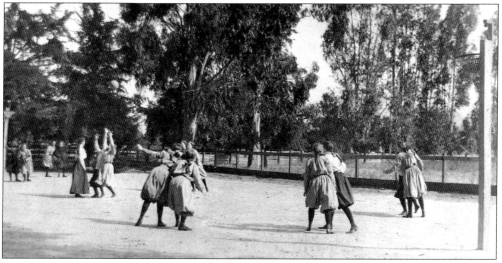

Students practice playing one-on-one basketball during physical education class at Curtner Seminary. Teams were larger and basketball was still mainly a passing game in 1896. At closer look, the nets in the photographs are little hammocks and the ball would have to be popped out from below after a basket was made.

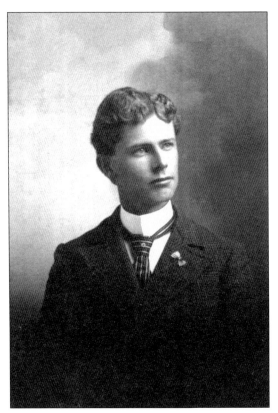

J. Haley Durham graduated from the School of Dentistry at the University of California-San Francisco in May 1897. He immediately set up practice in Irvington, renting from "Pa" Ford, the druggist at the Corners, and stayed there for 54 years, working up to four cranked chairs. His hobby was photography, and many of the documentary pictures in this book are his. He was widely admired for his quiet leadership and integrity, and served for many years on the Unified Sanitary District and in other capacities in the community, wherever he was needed.

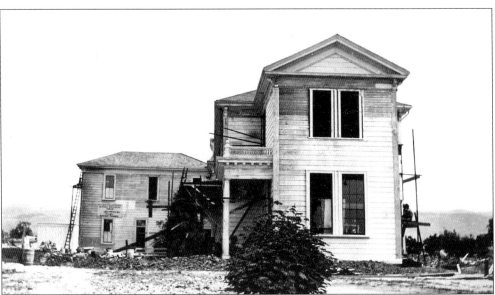

The Curtner Seminary attracted such widespread notice that new buildings were planned. Then on July 4, 1899, a disastrous fire destroyed the main structure. Mrs. Ingram was the backbone of the seminary, and when she contracted a fatal illness it permanently closed. Anderson Academy took over the property later that year. Hirsch Construction, seen here at work, installed the latest in plumbing for the opening of the military academy in 1900.

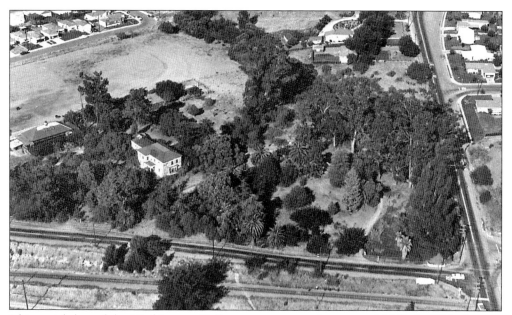

This aerial shot of the Washington College campus was taken around 1960. In 1910, the new Western Pacific Railroad acquired right-of-way for a second track, paralleling the Southern Pacific. This meant cutting into the slope and moving Driscoll Road to the east. By 1960, only the college building and Gottschalk gymnasium (constructed in 1900) remained of the campus structures, along with the original ball fields in the upper left.

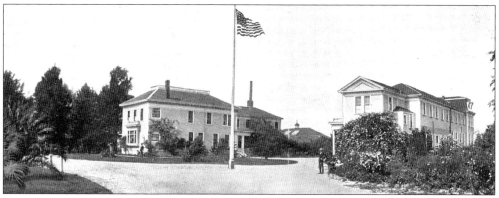

The college was rebuilt as an elite military academy in 1900, when William Walker Anderson moved his University Seminary to Irvington from Alameda and renamed it Anderson Academy. Rev. James McCullough sent his son to this school and stated, "Mr. Anderson was a well-known and admittedly fine educator and had long been principal of the Santa Cruz High School before organizing his own private school." (Leland Cutler, 1954.)

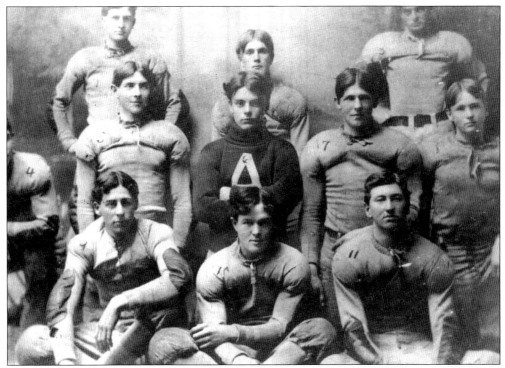

In 1901, the Anderson Academy football team was captained by Edwin D. White and Leland Cutler played center. In 1907, the team played St. Mathews, Trinity, Alameda, Berkeley, Oakland, Tamalpais, and Fruitvale in league play. Most Anderson graduates went to the University of California, Berkeley. In 1903, Leland Cutler entered Stanford, where his sister was already attending, and later became president of the board of trustees of the university.

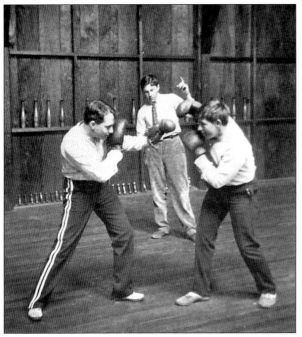

Two students box in the gym at Anderson Academy in 1901. Leland Cutler describes in his memoirs, "My uncle, W. W. Durham, whom I called 'Uncle W.,' had watched Fay (Chadbourne) and me boxing and . . . gave me a set of boxing gloves . . . Fay was really good and won an amateur championship at the Olympic Club [San Francisco]." Cutler also describes in his memoirs seeing the June 1896 Corbett-Sharkey exhibition bout in San Francisco.

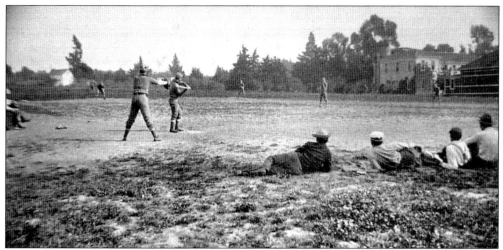

Today the playing fields at Anderson Academy are the north portion of Timbercreek Terrace. The dark redwood building to the right was a new gymnasium designed by Charles E. Gottschalk, architect for Villa Montalvo, the country estate of James Duvall Phelan. "Anderson Academy had very good football and baseball teams regularly defeating Washington High School at Centerville." (Leland Cutler, in *American Has Been Good to a Country Boy*, his 1954 memoir.)

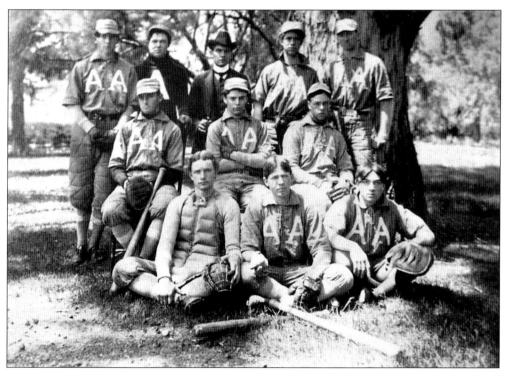

In 1902, the Anderson Academy baseball team was managed by Guy Sharwood Jr., captained by pitcher W. M. Sell Jr. Leland Cutler (with mask) and M. Titus alternated as catcher, since Frank Chance was still playing the backstop position with the Chicago Cubs. The Durham and Cutler families followed Chicago news by always having the *Chicago Tribune* at the dinner table, discussing its contents and debating issues during the meal.

While at Anderson Academy, Leland W. Cutler played a silver cornet, acquired from the leader of the Colusa Silver Cornet band in 1896. "The only lessons I had from the start were from my mother and she taught me from the standpoint of the fundamentals of music and how even the cornet must blend into the making of a harmonious whole."

In 1914, the college campus became the private home of the Anderson family, which they called Bonnie Brae, the Scottish term for a beautiful hillside setting. In the June 26, 1915, *Washington Press*, it was reported that "Mrs. W. W. Anderson of Irvington received thirty or more of her friends at a lawn party on Friday afternoon of last week. The day was ideal and the grounds about "Bonnie Brae" were at their best . . . light refreshments were served at small tables set about in the shady nooks before the company dispersed."

Three

IRVINGTON THE BEAUTIFUL
1886–1914

By 1900, the Gallegos Wine Company Building was almost hidden by Canary Island Palms. Gallegos purchased the Beard ranch in 1881, planted a record 600 acres of vineyards, and designed irrigation systems. Land sales helped finance the winery construction, which was the biggest in the state at the time. Healthy vineyards on phylloxera-resistant rootstock survived on some of these lands until 1953. (Courtesy Durham Collection.)

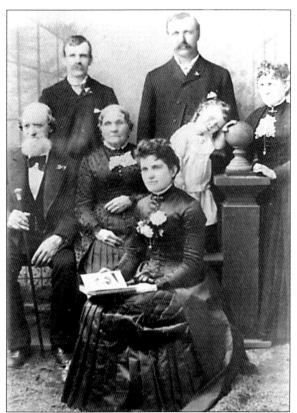

The Macks celebrated their 50th wedding anniversary in 1886. Pictured, from left to right, are (first row) Martha Mack; (second row) William Mack, Anna Mack, and granddaughter Jenny McKean; (third row) George Washington Mack, Edward Julius Ismert, and Sarah Mack McKean Ismert. Edward Ismert and George Mack were in partnership for a grain-crushing mill in Irvington that was built using timber delivered to Mowry Landing.

The Threlfalls celebrated their 25th wedding anniversary in 1886. Pictured, from left to right, are George Threlfall (student at Washington College), Helen Rix Threlfall, Nellie Threlfall (Benbow), Charles Threlfall, Richard Threlfall, and Angie Threlfall (Millard.) They had one of the finest model farms in Washington Township, as well as a large scale cattle and sheep ranch in Stanislaus County.

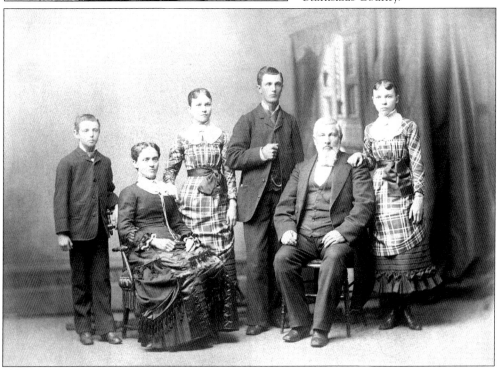

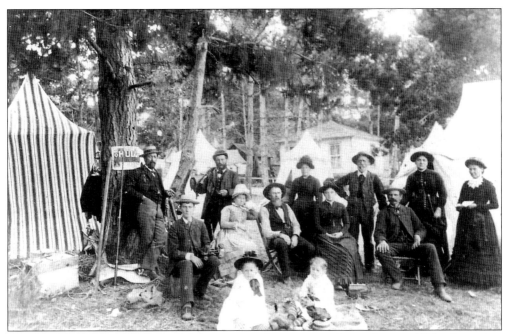

The local press reported about "Washingtonians" camping at Santa Cruz in 1882, where they celebrated the crystal (15th) wedding anniversary of Mr. and Mrs. Babb. The Crowell, Osgood, and Rix families are part of the group; the Rix children are in front. Wonderful meals were prepared by their cook Ah Sing and were described in the weekly paper when they returned, as was a list of all their presents. Travel was by several wagons, with the cook wagon at the front.

Grandma Hinkley came from Maine and was related to the Osgoods by marriage. In the 1890s, Miss Rose Hinkley was in Irvington and her advertisements in the local paper stated, "Fashionable Millinery Emporium, Keeps a large and well assorted stock of trimmed and untrimmed Hats and bonnets, ribbons, feathers, flowers, laces & hats and bonnets trimmed to order in the latest style, at short notice and at most reasonable prices."

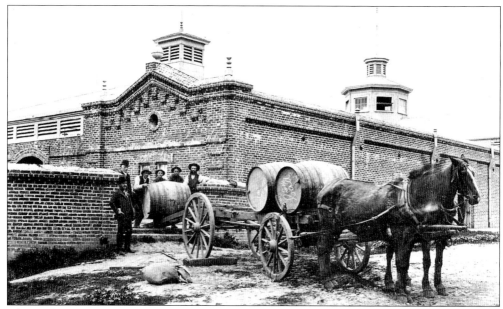

The Gallegos Wine Company started in 1881. One source notes that Eduardo Bale of Napa, grandson of Mariano Vallejo, was manager of the construction team. Gallegos applied the engineering methods from his efficient coffee plantations in Costa Rica and Guatemala to this California winery. The gravity-flow design meant that wagonloads of grapes entered at the back of the third floor, brought in from vineyards just up the road.

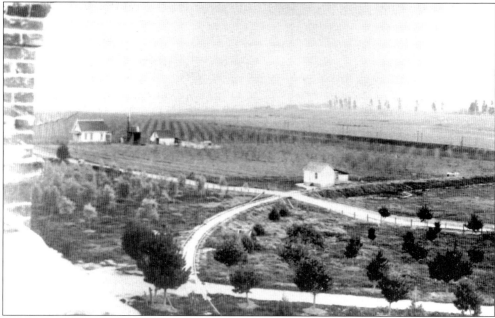

This front view of the winery shows the wagon roads that curved down from the front of the building to the Southern Pacific Railroad. The barrels stacked on the front loading area and rail cars wait on the rail spur to be loaded with the finished product. At this time in California, almost all commercial wine was sold, packed, and shipped in barrels at the winery and the bottling was done in San Francisco. The majority of the grapes grown were Zinfandel.

The Gallegos Wine Company distillery is on the far right. Dr. E. W. Hilgard had his test vineyard up the road and was an adviser to Gallegos. In 1892, the winery was purchased by Gallegos's brother-in-law, Carlos Montealegre, renamed Palmdale Winery, and joined the California Wine Makers Corporation. In 1900, the winery was leased to the California Wine Association.

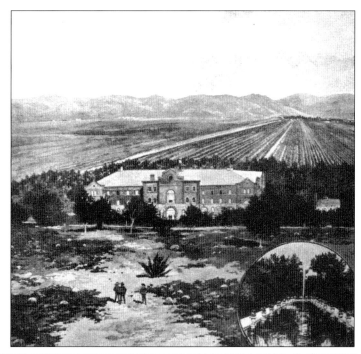

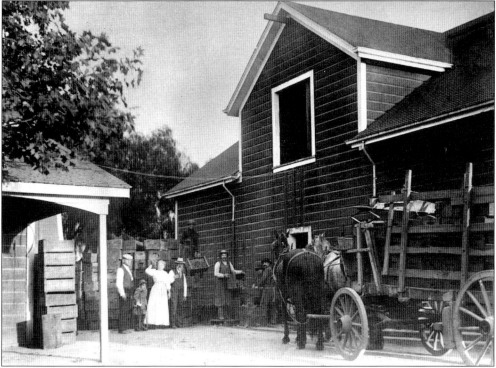

Los Amigos Winery was bordered by Washingtonia palms on Washington Boulevard. On March 4, 1916, the *Washington Press* progressive edition noted, "Los Amigos Winery and Vineyards of Grau and Werner being one of the finest [winemakers] of the state. It has 100 acres of grapes the plants for which were selected six years ago in France, and the winery has a capacity of 100,000 gallons."

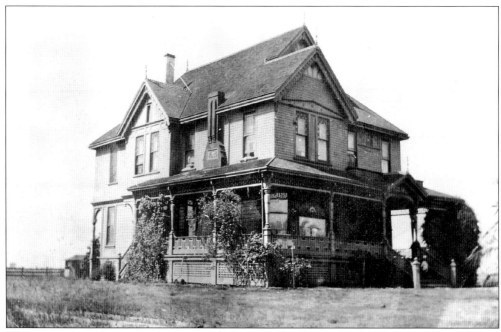

The Martin Carter home was photographed after 1892, the date on the chimney. An Irish immigrant from Galway, Martin Carter was in charge of car design and shop operations for Carter Brothers in Newark between 1877 and 1900. Today the Society for the Preservation of Carter Railroad Resources (SPCRR) is located in Ardenwood Historic Farm Regional Park in Fremont.

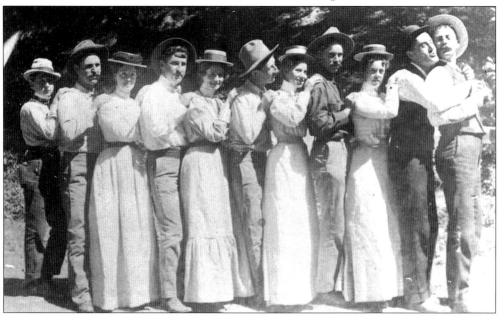

Martin Carter's sons and their friends posed for this 1890s photograph as the "Carter Crowd." The oldest sons, T. N. and F. M., inherited the family estate when Martin died in 1908. Estate attorneys Peter J. Crosby and Thomas J. Powers distributed the estate from their Oakland offices. The estate listed hundreds of prime trotting stock, as well as specialized breeds of work horses, particularly Percherons.

This engraving shows the action of the American trotter. Martin Carter purchased the Walker farm for his famous Nutwood Stables. He bred champion trotting horses, such as California Nutwood and Nutwood Wilkes, and raced against trotters sired by Stanford's Electioneer of the Palo Alto Stables. In 1891, his horses made times of 2 minutes, 20 seconds in the mile at the California State Agricultural Fair. Great races were held at his racetrack that is near today's Irvington Community Center. (Courtesy Jill Singleton.)

Olive Benbow sits with friends in her four-wheel horse cart outside Thomas Powers's home (with the white picket fence), near the present Leal Theater. The roads were alternately muddy and dusty since they weren't paved until around 1920. People complained that the automobiles went too fast, over 20 miles an hour. Wallace Beery, from the Essanay studios at Niles, was one such racer on jaunts to San Jose.

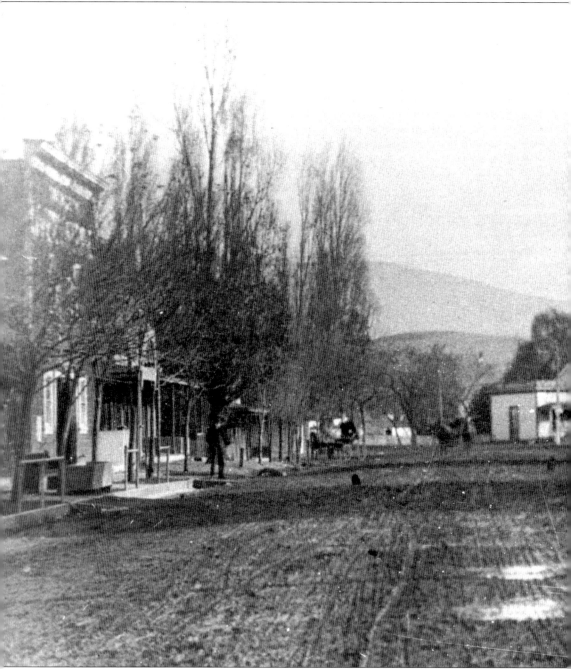

This *c.* 1900 view looks south toward the Corners on wet and muddy Centerville road. The Bradstreet Directory noted that Irvington had a population of 467 in 1907. Listed were the San Jose Branch of the Southern Pacific Railway and the agency for the Wells Fargo & Company Express; Eugene N. Babb & Company, the general store; George T. W. Cokely, the butcher; R. C. Crowell, the stationer; P&L De Vaux, providing wine; H. D. Ford, the jeweler; Grau and Werner had a vineyard; W. H. Jackson, a tailor; Charles A. Lutz, the druggist; Ed Roderick, with a saloon; C. F. Petersen, the shoemaker; and M. E. Mattos, the blacksmith. The two-story buildings, from

left to right on the west side of the street, are the Old Corners, Clark Hall, the Hirsch building, and the IOOF hall. Other businesses in Bradstreet's list include A. B. Hirsch, the saloon; W. W. Hirsch, hardware and furnishings; O. N. Hirsch and Company, the general store; A. O. Rix, the wheelwright; J. M. Scanlan, the butcher; Thomas Tierney, the blacksmith; and H. E. Walsh, the livery stables. Among those listed in the newspapers were the new Chadbourne garage and dentist Dr. J. H. Durham.

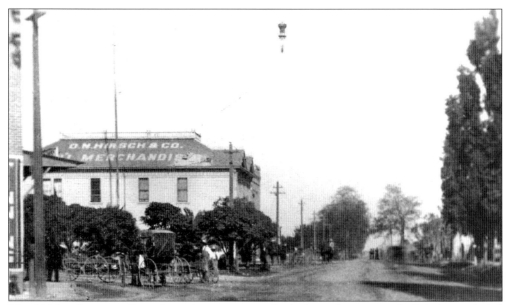

The 110-foot Irvington flagpole can be seen soaring high above the trees on the left that included some Japanese Incense Cedar (Cryptomeria japonica). The trees on the right were Eucalyptus, planted for shade, in front of the Mack house and store. Perhaps the most interesting detail in this picture is the solitary light bulb hanging over the intersection that helped wayfarers in the dark a decade before the lighted traffic station was installed in 1917.

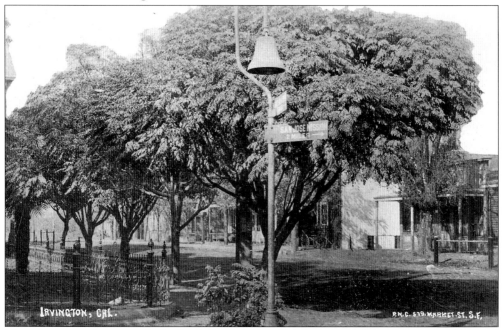

Then known as Irvington Park, the little triangle of land at Bay Street and Centerville Road was edged with cast-iron railings and graced by both its massive flagpole and the El Camino Real bell (put up in 1909). The signpost points east toward the San Jose Mission, up the hill and south to San Jose, 13 miles away. A Washington fan palm (Washingtonia robusta) was planted in the park on the left.

C. Frederick Horner and his wife are in the first electric car in the township, which was a one-cylinder, eight-horsepower Thomas. He was the only member of the Horner family to return from Hawaii to live in Irvington; their "pretty cottage, with handsome grounds" was on Irvington-Centerville Road. C. F. Horner was elected to the county board of supervisors in 1901 and served two terms, and was involved with the development of year-round, functional roads.

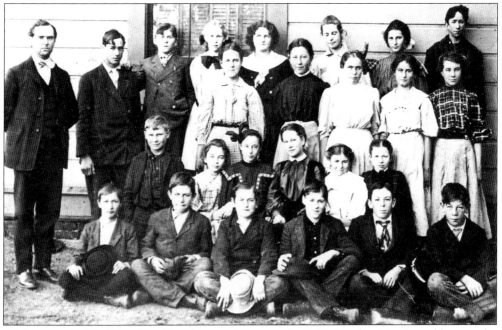

Washington Public School and its older students pose in 1909. Teacher Mr. Reynolds is on the far left, and Randall A. Griffin stands next to him. Dr. Nellis's daughter Edith is the tall, fair girl, third from right in the third row. She attended Washington Union High School until she was 17 years old, before marrying her father's substitute, Dr. Elmo Grimmer, who later took over the practice.

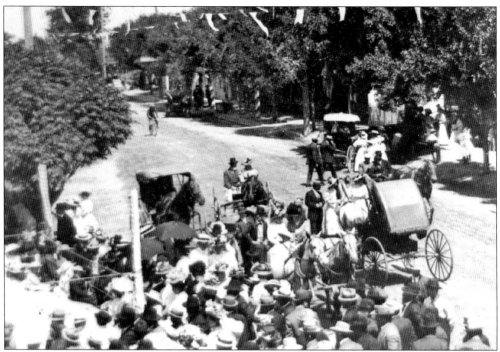

In the June 26, 1905, *San Francisco Examiner*, it was stated, "The whole population of Washington Township in the County of Alameda have made up their minds to enjoy one of the old-fashioned Independence Day celebrations on the coming Fourth of July, a grand barbecue will be one of the prominent features of the occasion. Early in the morning a special feature will begin the day's ceremonies. It has been titled 'Unfurling Old Glory to the Breeze.' . . . One native daughter, Mrs. I. R. Straven (Julia Rix) will read the declaration of Independence. Another native daughter, Miss Rose Sunderer will sing the 'Star-Spangled Banner.' Hundreds of native boys and girls will sing patriotic choruses and Alexander Sheriffs (winner of the Carnot Medal, a debate award founded by the founder of the modern Olympics) of Stanford University will deliver the oration, followed by 'America' sung by the audience." The orator in the photograph below is local lawyer Tom Powers.

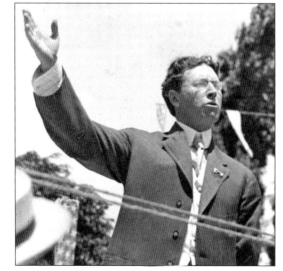

In the same edition it was also stated, "The barbecue begins at noon and ends when all the provisions are exhausted. A spirited contest was held throughout the township for the selection of a young woman to represent the Goddess of Liberty. Ten thousand votes sent, with the majority naming Miss Olive Benbow, the daughter of a prominent farmer to occupy the Goddess of Liberty float. Japanese wrestlers have been engaged, a 'greasy pig' is been fattened and greased. A baseball match is to be played between crack teams, the Crown Flours of Irvington vs. the Newarks. A dancing pavilion on the Palmdale grounds is now in the course of construction. Fireworks, a grand ball in the evening at Clarke's Hall and a 'horribles' parade are among the pleasures of the occasion."

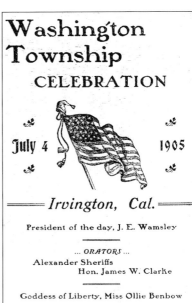

Washington Township
CELEBRATION

July 4 1905

=== *Irvington, Cal.* ===

President of the day, J. E. Wamsley

... *ORATORS* ...

Alexander Sheriffs
Hon. James W. Clarke

Goddess of Liberty, Miss Ollie Benbow

Grand Marshal, Hon. C. F. Horner

Special train leaves Irvington for San Francisco and Way Stations at 10.25 P. M.

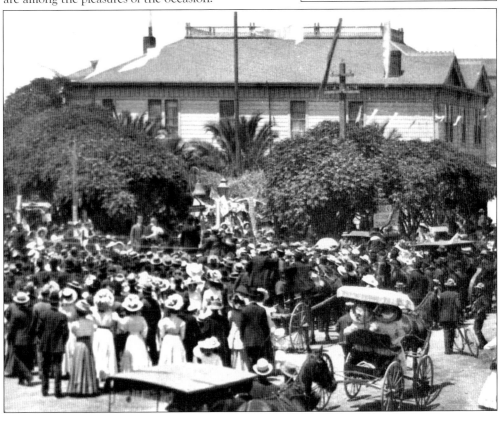

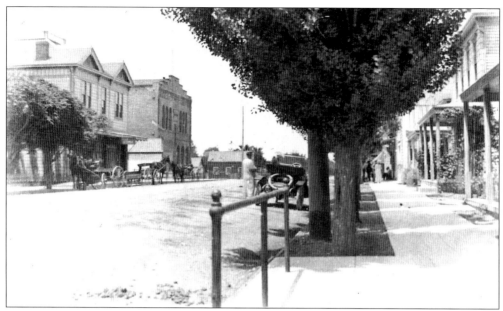

Street trees and a raised sidewalk grace the front of the Mack house. In 1911, the ground floor became the Irvington Branch of the Alameda County Library. Miss Martha Mack lived upstairs for many years and later her niece Anna Van Buskirk occupied it as well. The cast-iron stanchions to tie horses and wagons were sturdier than earlier wooden stanchions, but they were needed less and less over the next decade.

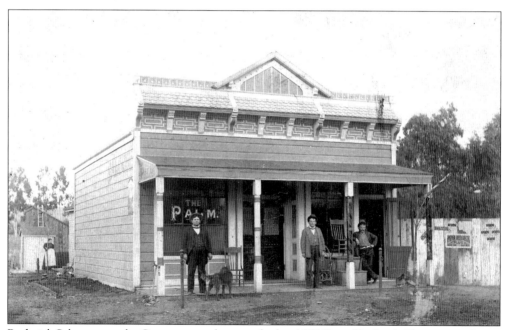

Roderick Saloon, near the Corners, was photographed in 1907. Piper Heidseck Champagne Cigars are advertised on the wall at right. On the back of the image is a message to a member of the Rasmussen family that says, "Ma is standing near the shed. This was before you made the livery stables. Years before you or Geo." (Courtesy Jackie Philips.)

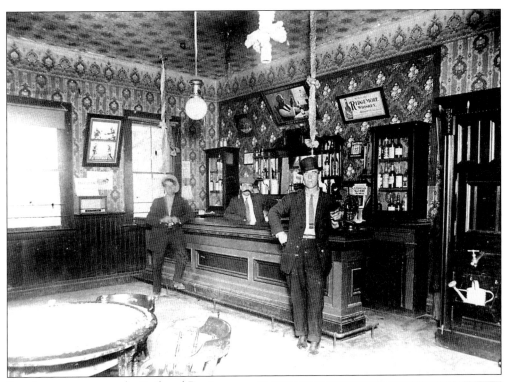

For almost a century, the Railroad Bar in Irvington was next to the tracks on the north side of Washington Boulevard. The framed picture on the far wall has some famous boxing bouts from around 1900. Curiously, a watering can is located below a water faucet (far right). This building was lost to the BART overpass project in mid-2005.

Dr. Elmo Miller Grimmer came to Irvington from Hillsborough in 1910 after his graduation from Parnassus Heights in San Francisco. His first child was also named Elmo, but Dr. Grimmer called the baby Chuck. The Grimmers' first home was just north of the new Alameda County Bank at the Corners. Chuck Grimmer (1914–2005) grew up to be a dentist, setting up practice in Centerville. (Courtesy Chuck Grimmer.)

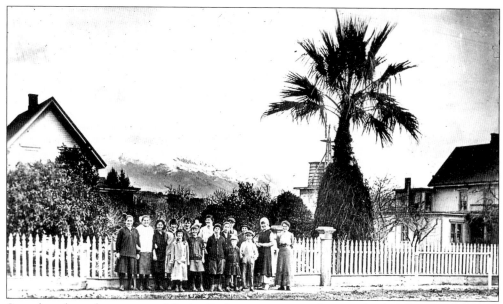

Snow has always been rare on Mission Peak, so it was a good reason for this class of students to be out with their teacher. The Montross home on San Jose Road was behind the group. A. B. Montross first settled north of the Corners in 1850. Mrs. R. A. Griffin noted in 1950 that the lumber for old homes such as this was brought "around the Horn, package style" and can be recognized "by their clabberd."

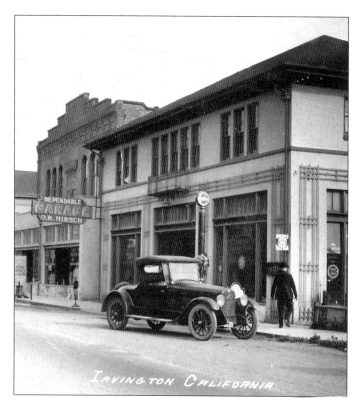

One of Otto Hirsch's early businesses was the Dependable Garage. The single gas pump is the tall, cylindrical pole with the round sign on top, positioned next to the car. The trellis on the new building was a nice touch, even if vines were not meant to actually grow on it. The IOOF building to the left had a part of its upper façade repaired after the 1906 earthquake.

A Millard family photograph records an early physical education class at Washington Public School. The children are using Indian bats that were sold in Spalding and other sporting goods catalogs. The girls always wore middy blouses with black leggings, no matter the temperature. Indian bats were one of the fitness crazes of the day, and can also be seen in the photographs of the gymnasium at Anderson Academy.

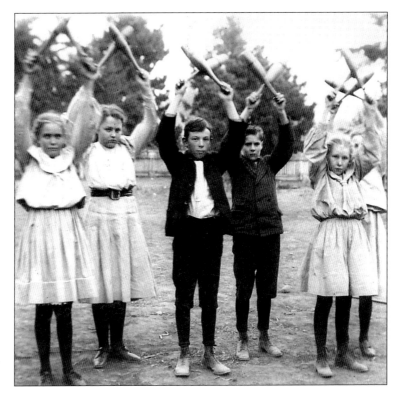

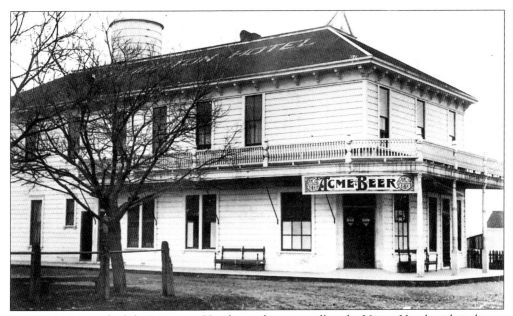

In 1892, Irvington had the Irvington Hotel, seen here, as well as the Union Hotel, with its livery stables. A victim of fire in 1916, the Irvington was rebuilt and remained standing until 2005. The Raymond family bought it in 1921, when they moved to Irvington to work at the new PG&E station near Albrae. They owned it for 23 years. Some recall there was an open area behind the first hotel where semiprofessional baseball was played.

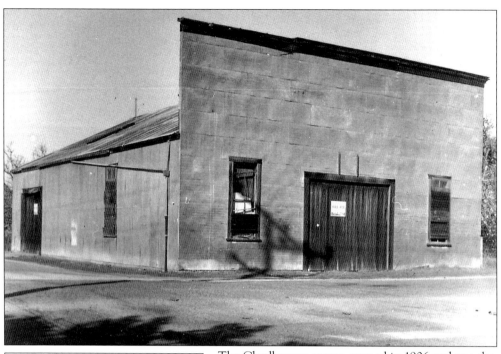

J. F. CHADBOURNE

AGENT FOR

Rambler Touring Cars

AND RUNABOUTS

IRVINGTON, Alameda Co.

California

Repairing

The Chadbourne garage opened in 1906 and was the first in the township. Every time Joshua Chadbourne sold an order for a car, it was announced in the local paper, along with the names of those who ordered the car, the make of the vehicle, and how much was paid for it. Chadbourne also owned a fruit ranch, known for its apricots, on the south side of Driscoll Road. Chadbourne Elementary School was built in 1960, replacing some of his orchards.

Bess Lowrie, her sister, and their mother hike to the top of Mission Peak in 1900 to begin the new century. E. W. Hilgard co-wrote a popular textbook for schools in 1910, *Agriculture for Schools of the Pacific Slope*. It described the science behind everything, even the importance of exercise by stating, "Nothing helps so much to make us well and strong as deep breathing . . . hill climbing can train these muscles."

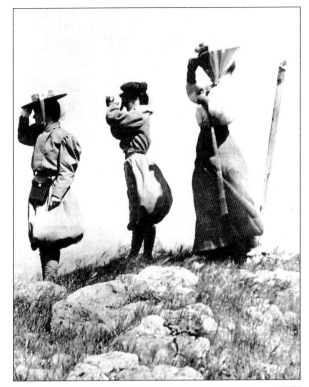

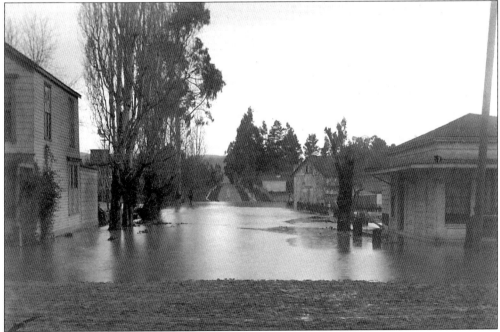

The creek from the lagoon often flooded during peak rain events around Union Street, where it connected with the creek that runs through the college. After the flood, the Mack family installed raised paving around their house and store. The flood went right up to the sills of Dr. Durham's dental office. (Courtesy Durham Collection.)

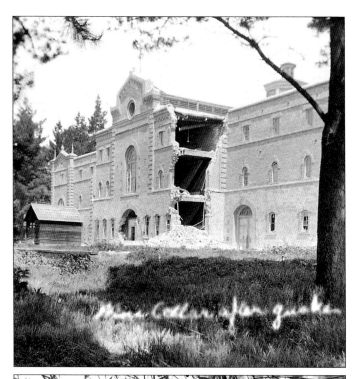

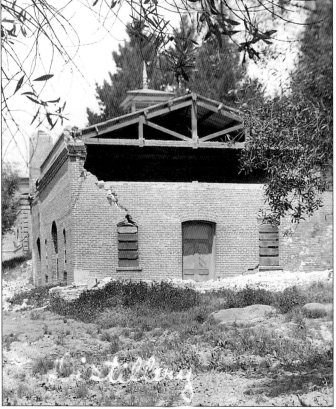

The April 18, 1906, San Francisco earthquake was felt as far away as Nevada. The effect was magnified where buildings straddled fault zones, such as the Palmdale Winery on the Hayward Fault at Irvington. The wine cellar was not in use as the winery was in transition; Henry Lachman, one of the board members of the California Winery Association (C.W.A.), acquired it the previous year. The C. W. A. cellars in San Francisco suffered major loss of their inventory. J. Haley Durham took these two photographs shortly after the earthquake of the damage to both the three-story winery and the much smaller distillery. The remnants of what was once the largest winery in California was demolished, at a time when many wineries in the state were just being built. (Courtesy Durham Collection.)

These photos were taken by Dr. Durham six months after the earthquake, when the winery was being demolished. It was well built, and razing each section took a long time. Henry Lachman was able to sell the undamaged cellar vats and other equipment to the C. W. A. for its new facilities at Winehaven at Point Molate, which then became the world's largest winery until it closed with Prohibition in 1919. The Palmdale Winery demolition debris likely went for landfill. Until 1910, with the construction of the new Western Pacific Railroad, the winery land led up to the railroad depot; the railcars that once loaded barrels of wine on the Gallegos spur line were likely used to load the broken brick. Lachman retired to the Palmdale estate in Mission San Jose, where he died in 1915, and his heirs lived there until 1927. (Courtesy Durham Collection.)

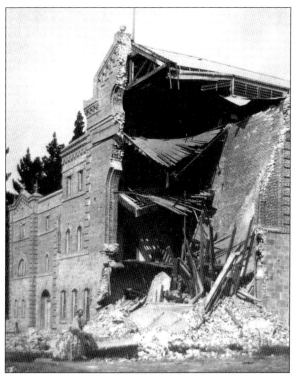

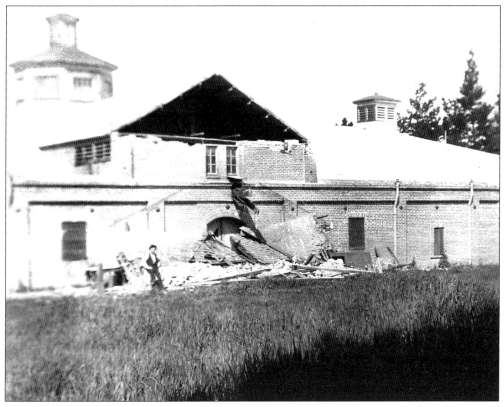

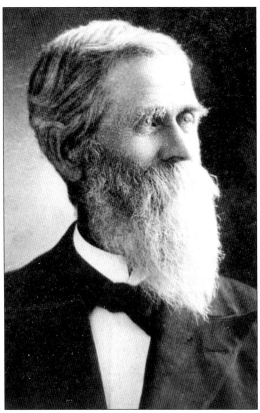

Rev. Judge D. Durham poses in 1910 with an undimmed twinkle in his eye. The *Washington Press* reported on November 18, 1910, "Frank Chance, the celebrated baseball manager of Chicago [visited] Rev. J. Durham and family Thursday. Frank was once a student at the old Washington College of Irvington and has ever a soft spot in his heart for the old town and his friends here." In 1910, Frank Chance also published his baseball novel *The Bride and the Pennant.* (Courtesy Durham Collection.)

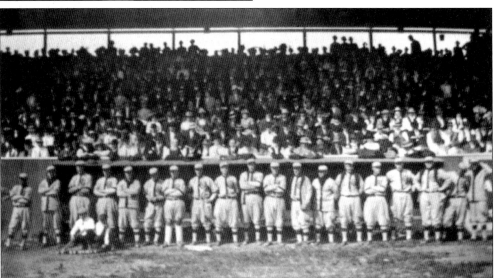

Frank Chance brought his Chicago Cubs to play on a barnstorming tour of California in October 1905, stopping in Fresno, his hometown. Irvingtonians went down to watch the game, and one of them took this snapshot of the Cubs in front of the stands. Chance appears to be sixth from the right. In 1906, he led the Cubs to a team record of 116 victories, a feat still unsurpassed today. When Fresno rejoined the Pacific Coast League in 1933, the city built a new baseball park and named it Frank Chance Field.

Frank Chance was in fine throwing form at first base in 1913 in his first season with the New York Yankees, the team's inaugural year at the Polo Grounds. Unfortunately, owner Frank Farrell was not prepared to finance the cost of building a team from the ground up, as he had built the Cubs a decade earlier. Chance was manager and part owner of the Los Angeles Angels at Washington Park in 1915 and 1916 (the year they won the Pacific Coast League pennant). In its April 1912 issue, *Baseball Magazine* described a visit to the Chance orange groves, "The field, a most excellent one, was as large as the majority of major league parks. To be sure, ground rules were made necessary by the presence of trees in center and left field, but this did not prevent a number of brilliant fielding shots." James L. Jeffries, former heavyweight champion of the world and close friend of Chance, umpired the bases for this game of "orchard ball." On July 10, 1910, Franklin P. Adams, New York columnist and translator of Greek poetry, first published his poem "Baseball's Sad Lexicon" with its famous line, "Tinker to Evers to Chance." Years earlier, the press had nicknamed him "The Peerless Leader" for his ability to lead his team to victory from his position on the field. (Courtesy Jill Singleton.)

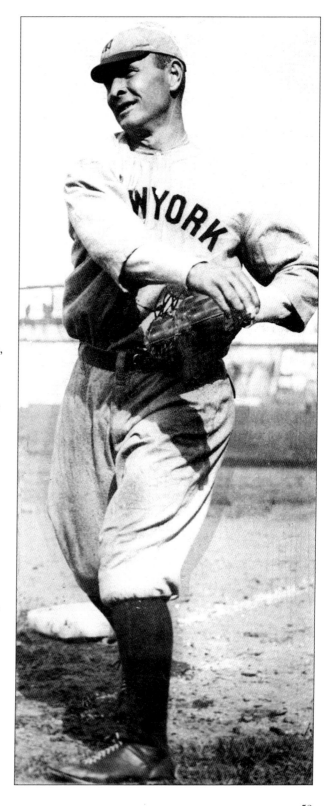

Aided by ease of irrigation, the Driscoll strawberry farmlands extended on both sides of Driscoll Road by the 1930s, benefited by the longest growing season in the United States. The original strawberry fields were next to Mission Creek and this photograph shows how far east they

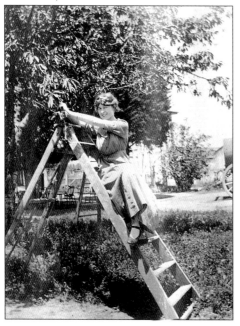

Alice Carlson is pictured here on a fruit-picking ladder at the Copeland house around 1915. At right is the horse-drawn, water-sprinkling cart used by Frank Copeland to keep dust down on the road in the dry season. Copeland was the tax assessor for southern Alameda County, which required regular travel to all the farms, dairies, and wineries, in addition to farming his own tomatoes for cannery contracts. (Courtesy Earlene Walker.)

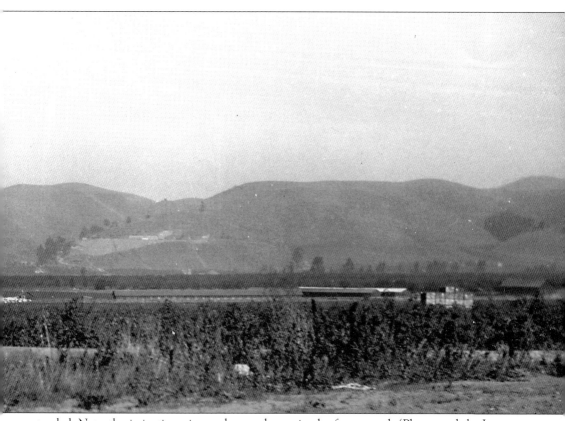

extended. Note the irrigation pipe and pump house in the foreground. (Photograph by Laura Thane Whipple.)

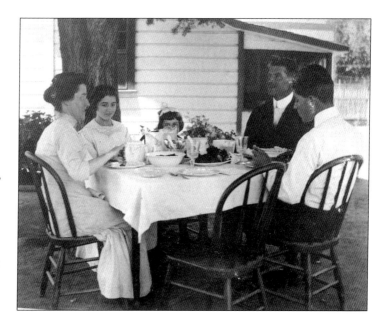

The Copeland family dines outside in the shade of their house and fruit trees around 1915. The land was in the Lyons/Copeland family for several generations. Pictured, from left to right around the table, are Anna Lyons Copeland, daughters Velma and Viola, husband Frank, and son Ray. Father Raymond served with the U.S. Army as a chaplain in World War II, and was with Gen. Mark Clark at Berchtesgaden.

The Haley and Mabel Durham home was built at 42539 Osgood Avenue in 1914 on the same site as Haley's childhood home. His father, Reverend Durham, died tragically earlier that year in a train accident. The Durhams rebuilt on the site of the 1889 family home, drawing upon the Durham connections in Chicago for this distinctive Prairie-style house, which is still standing and is now owned by the City of Fremont. (Courtesy Durham Collection.)

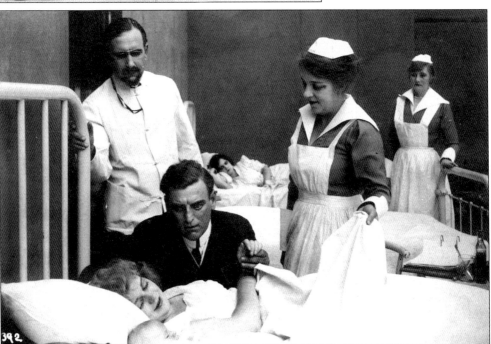

Stivers descendant Gilbert Scott (the baby in the foreground) had a role in the 1914 Broncho Billy movie *Her Return*. His father owned Scott's Shoes in Niles, two blocks south of the Essanay film studios. Pictured, from left to right, are the mother, played by Marguerite Clayton; the doctor, played by Lee Willard; the husband, played by Gilbert M. Anderson; the patient; nurse Eva Heazlett, played by Eva McKenzie; and a second nurse. There was no hospital near Irvington until Washington Township Hospital was built on the Stivers-Marshall farmland in 1954. (Courtesy Cynthia Scott.)

The Irvington Library was in the Mack house by 1911 and moved to 530 Broadway in 1953. In 1956, it moved to Mission Street (renamed Washington Boulevard that year), and six years later it was located at 4 Rick Mark Center. The branch moved to Blacow in 1971 and finally to the Irvington Community Park in 1985. The Wally Pond Community Center opened in the community park in 1996.

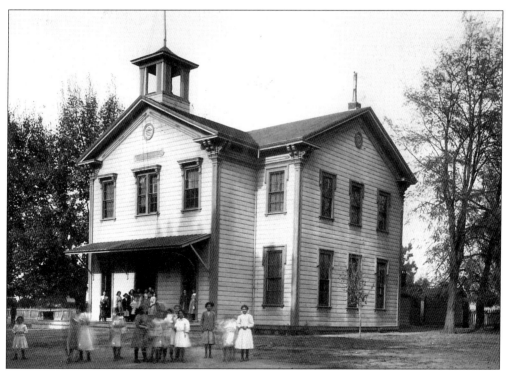

Washington Grammar School was built in 1875 and was photographed with its growing student body not long before a move to new facilities in 1922. The property reverted or was sold to the Reorganized Latter Day Saints, who held summer meetings there for decades. A Berkeley family came in late spring to weed, dust, and straighten the area up for a summer encampment for church members. Everyone stayed in tents on the grounds.

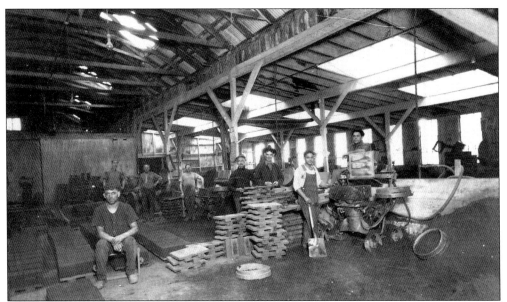

The Reid Brothers hospital equipment factory was started at 3490 Union Street after World War I to make metal hospital furniture with a baked enamel finish. Otto Hirsch helped local interests put together the land deal to attract the industry to Irvington. The company was led by president P. C. Hansen, vice-president Thomas Tierney, superintendent L. C. Walters, and general manager Philip Ablan. Frank Moniz was one of the factory workmen.

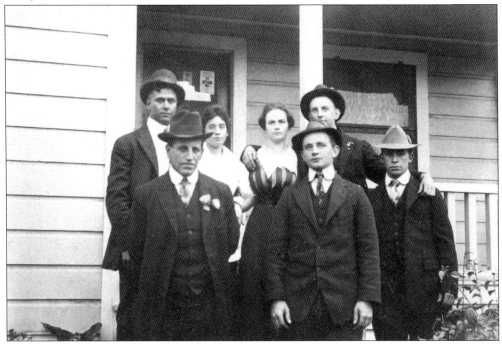

During World War I, the Geary siblings and friends stand in front of the Geary farmhouse, where stars in the window note military service in the family. Pictured, from left to right, are (first row) John Geary, unidentified, and Dod Geary; (second row) Bert Cook, Rose Geary, Nell Geary, and Ed Maloney. (Courtesy Pat Schaffarzyk.)

Four
FRUITED PLAIN
1915–1946

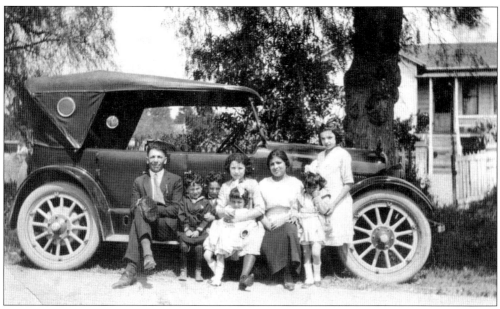

Joseph and Maria Nunes sit with their young family on Filbert Bettencourt's runabout in front of their home on Roberts Avenue in 1920, which was surrounded by apricot orchards. Joseph made and repaired shoes at his shop on Mission Road (Washington Boulevard). They were one of many families that emigrated from the Azores around this time. Pictured, from left to right, are Joseph, John, Joe, Dee, Patsy, Maria, Rose, and Mary. (Courtesy Alberta Nunes George.)

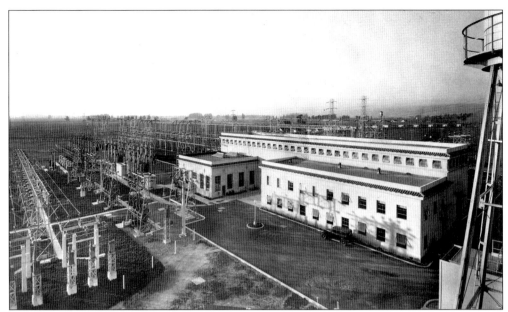

By 1902, electricity powered from the Mokelumne River passed through Irvington in a single line on its way to San Francisco. By 1909, the voltage had increased to two power lines, and in 1918 a transformer substation was built in the Irvington area near the Albrae stop on the rail line running south from Newark. By the late 1920s, it was connected to Yosemite by massively scaled power lines and was named the Newark Substation.

The Leal Theater was built in 1922 and designed by architect Henry Minton, who had come to San Francisco fresh out of Harvard shortly after the San Francisco earthquake. Wally Pond worked at the Leal Theater in the 1920s, first as a janitor, then putting the rolls in the player piano (these came with the film, along with a score), and finally operating a projector where light was produced by connecting carbon rods.

Tom Geary and his nephew pose with a baseball bat and a collection of mitts and gloves at the Geary dairy farm in Irvington. So many players of Irish background were in the major leagues in the early years it was thought they had a special aptitude for the game. The same was said of successive waves of new ethnic players entering professional baseball. Judging by the smiles, the Gearys just enjoyed playing. (Courtesy Geary family.)

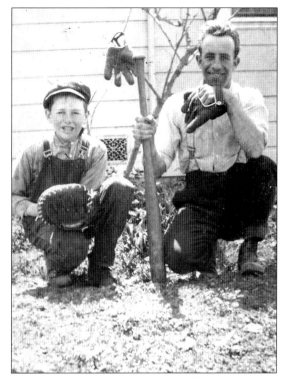

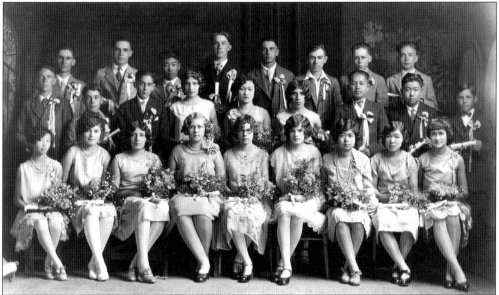

The 1928 graduation of the Washington Public School eighth-grade class was an attractive one, with greenhouse rose bouquets and a special photographer's backdrop to grace the scene. Pictured, from left to right, are (first row) unidentified, Lenora Nunes, Ann Bettencourt, unidentified, Mildred Durham, unidentified, Kiku Yamamoto, and Tsuruko Ichisaka; (second row) unidentified, George Azevedo, Joaquin Perry, unidentified, Kate Koya, Mabel Azevedo, Yasuto Kato, and Harry Nakagawara; (third row) Fred Houck, unidentified, A. Seghima, unidentified, S. Caldeira, two unidentified, and Gordon Pond. (Courtesy Durham Collection.)

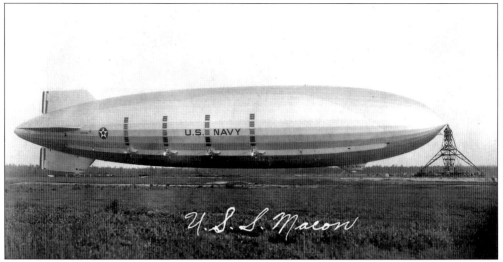

Airship USS *Macon* is photographed here before traveling to California in 1931. Moffett Field was a Naval air base from 1931 to 1935, then an Army Air Corps base until 1942. The Moffett Field land transactions were led by Otto Hirsch, with the vision and marketing of the airship base to Bay Area governments coordinated by Laura Thane Whipple. Otto took one of the first rides on the *Macon*. (Courtesy Jill Singleton.)

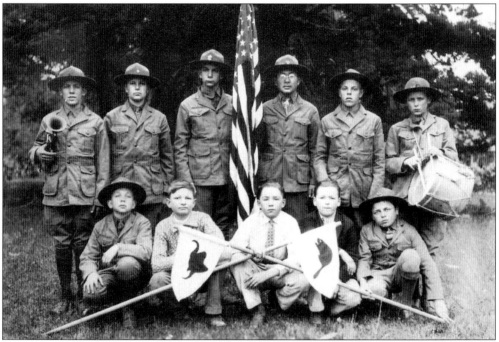

An Irvington Boy Scout troop in the 1930s was ready for the Camporee at Lake Merritt in Oakland. Pictured, from left to right, are (first row) two unidentified, Chuck Grimmer, and two unidentified; (second row) Frank Wipfli, unidentified, Wally Pond, Tsurue Sakaki, John Wipfli, and unidentified. Wally Pond completed his Eagle Scout award after high school and received the Silver Beaver for his life achievements in scouting leadership at Irvington. (Courtesy Dr. E. M. "Chuck" Grimmer Jr.)

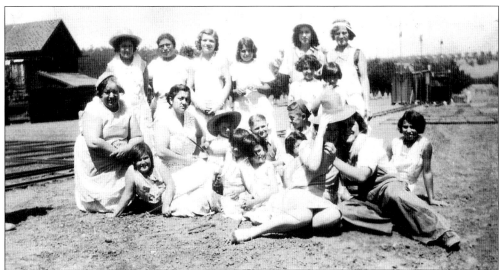

This photograph of the apricot-cutting team on Roberts Avenue is taken in the "dry yard" in 1931. Pictured, from left to right, are (first row) Eleanor George, Alberta Nunes, Mary Ann Silva, Beverly Furtado, and Agnes Raymond; (second row, starting with the hat) Albert George, Walter George, Leroy Raymond, and Patsy Nunes; (third row) Mary Silva, Mrs. Minnie Silva, Lucilla and Helen Correira; (fourth row) Madeline Furtado, Maria Nunes, unidentified, Rose Nunes, Evelyn Correira, and unidentified. (Courtesy Alberta Nunes George.)

Joseph R. Nunes stands in front of his shoe shop on the north side of Mission Road, opposite the entrance to Roberts Avenue. He created and repaired shoes, at a time when they were all made of leather and needed to last a long time. His craft as a cobbler was a highly valued skill in town. (Courtesy Alberta Nunes George.)

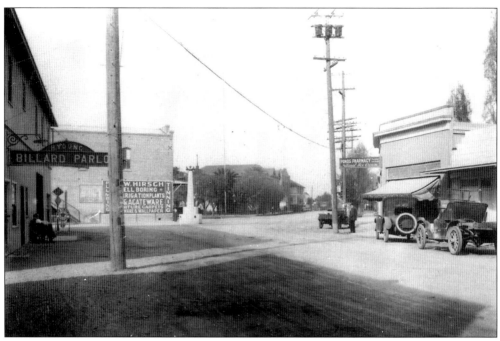

Shown here is a quiet early morning at the Irvington Corners in the 1920s. The corner garage at left hosts the H. Young Billiard Parlor, where the Berge Mortuary would later operate. The type of gasoline they served was Red Crown. Pond's Pharmacy is in the corner building across the way, advertising National Ice Cream. The edge of the canvas awning says "Irvington Pharmacy." "Pa" Ford specialized in watch repairs, an essential service.

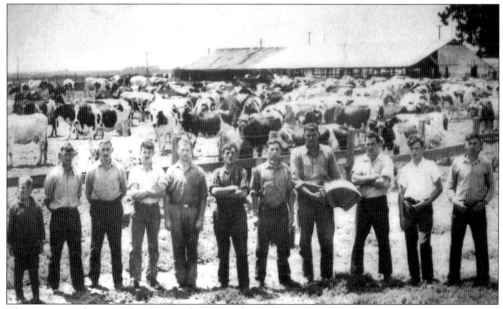

This is a rare photograph of Swiss dairymen from Albertsen's Dairy at Mowry Station in 1931. Pictured, from left to right, are cook's boy Teddy Amstalden, Tony Amstalden, Melchoir Amstalden, Arnold Inglin, Arnold Inderbitzen, Frank Inderbitzen, Tony Föhn, Moritz Schnyder, Carl Shelbert, and Franz Tony Schelbert. (Courtesy Pat Schaffarzyk.)

A 1930s aerial view depicts the agricultural village of Irvington and its outlying fields and orchards. The Works Progress Administration (WPA) produced a *Guide to California* as part of the Federal Writers Project. In 1939, they described Irvington briefly as follows, "Irvington, 16.8 m. (72 alt., 1,000 pop.), was Washington Corners in the 1870s and 1880s, when Washington College was one of the State's pioneers in industrial education."

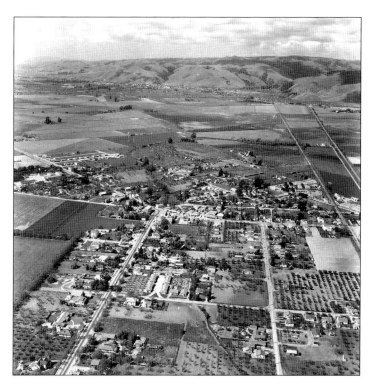

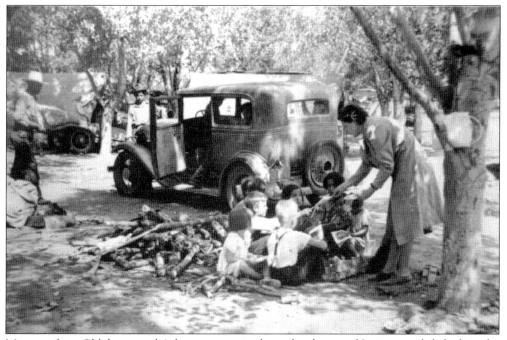

Migrants from Oklahoma and Arkansas camp in the orchards around Irvington while looking for work. Few people in California knew much about the terrors of the dust bowl until John Steinbeck's Pulitzer Prize–winning novel *The Grapes of Wrath* was published in March 1939. People can now learn about the hard times of that era at the new National Steinbeck Center in Salinas.

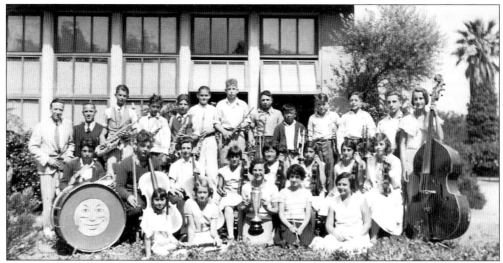

The 1932 Irvington Grammar School band musicians pose outside for a snapshot. Pictured are Margaret Brown, Carrie Silveira, Vernon Leal, Bernice Marshall, Sumi Ohye, Joseph George, Woodrow Goularte, Joseph Evulich, Billy Sinclair, Lorraine Houck, Charles Cheek, Genevieve Sinclair, Leroy Raymond, Billy Ritchey, Clarence Silva, Noburo Sugimoto, James Sinclair, Milton Durham, Malva Scammon, Jeanne Slater, Margaret Burger, Adelaide Oliveira, Alvin Muniz, and Albert Rose.

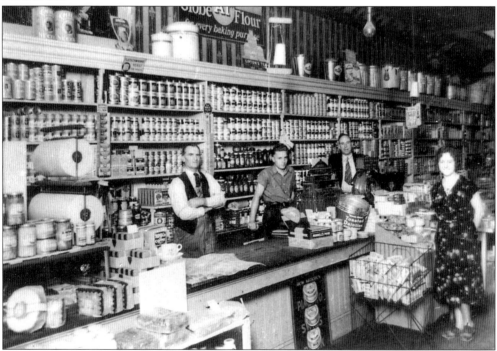

Tierney and Reynolds opened their grocery business in 1935 in Clark's Hall and were successors to W. W. Hirsch. Pictured, from left to right, are Henry Weston, Merv Blacow, Laurence Millard and Mrs. Blacow. The upstairs had been used only for storage since the 1906 earthquake, and the outer stairs were removed. They are carrying Campbell's soup, Kerr's canning jars, and Lipton's tea. Edward L. Rose purchased the building in 1942.

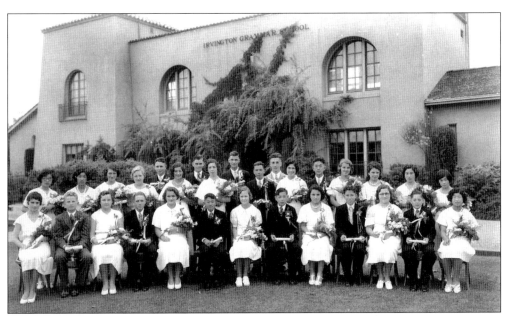

The Irvington class of 1933 is captured here for posterity. Pictured, from left to right, are (first row) Jean Slater, Curley Houck, Melba Scammon, ? Albertson, Serafine Bettencourt, Catherine Rathbone, Jimmy Koga, Abbey Harlan, Patsy Nunes, Robert Maggior, Irene Williams, Leroy Raymond, and unidentified; (second row) Grace Ura, Namia Tajima, Marcella Paniagua, Ruth Albertson, Jay Vargas, Bernice Borba, Shorty Cunha, Evelyn Marshall, Jackie Machida, Vivian Cunha, Rosie Nunes, Mary Hirabayashi, and Shizuko Sakaki; (third row) Albert Rose, Jimmy Sinclair, Jimmy Harlan, and Vernon Leal. (Courtesy Velma Valencia.)

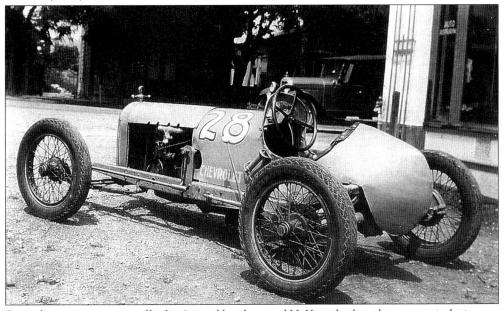

Several young men, especially the Amaral brothers and H. Kato, built early race cars in Irvington in the 1930s. This car is a Chevrolet Special by the Amaral boys. Wes Hammond documented some of their history in his 2004 self-published memoir, *Memories of Irvington, 1931 to 1943*. The closest racetracks he mentions were at Stockton and San Jose.

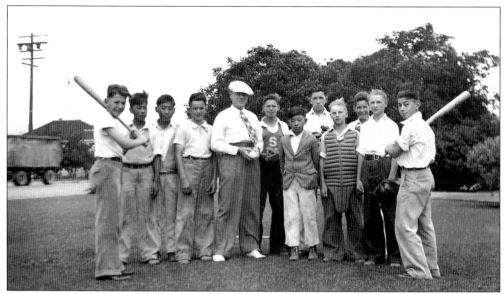

Irvington Grammar School joined the Washington Township Baseball League in 1936 and fielded 12 players. Team members included, in no particular order, George Nakamura, second base; Ben Kawata, center field; Chris Gomes, pitcher; Willie Borba, left field; Ben Mozzetti, right field; Alex Bier, first base; Walter George, shortstop; Richard Garcia, third base; Albert George, catcher; and John Ura, John Soares, and Melvin Garcia, substitutes. In 1936, a baseball team also developed among the fifth-grade girls, and Betty Corey won herself the nickname Babe Ruth with her ability to hit home runs.

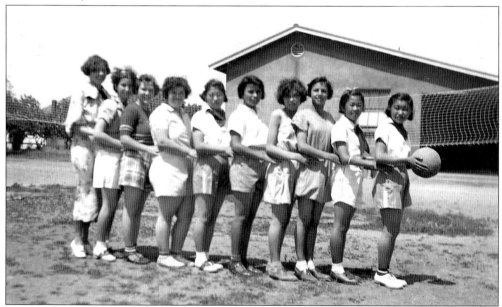

The undefeated Irvington Girls Volleyball team pose on their home court in 1936, with Miss Marcella Stivers on the left and Capt. Alice Nitta on the right. The other team members, listed alphabetically, include Edna Bier, Gloria Dycus, Eleanor George, Rita Lawrence, Gertrude Mozzetti, Alberta Nunes (sixth from left), June Sakaki, and Sachiko Tajima. The name Washington School District was voted out in 1926 and replaced with Irvington School District.

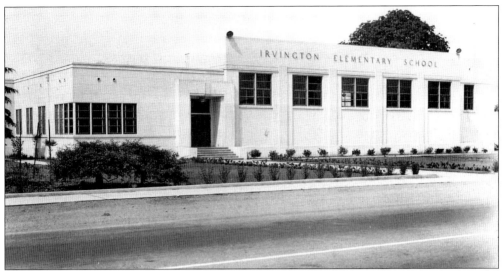

The 1940 Irvington Grammar School was designed by George Ellinger of Oakland for the Irvington School District that had merged with the Mowry Landing School District in 1939. It grew again in 1949 with a cafeteria and more classrooms. The Mission San Jose School District merged into the Irvington District in 1959. Dr. J. H. Durham was trustee of the Irvington School District from 1916 to 1932 and Durham School was dedicated in his honor in 1960.

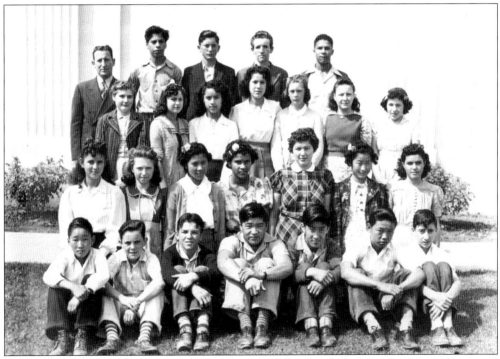

The 1941 list of graduates from Irvington Grammar School includes Dorothy Adams, Raymond Allendar, John Andrade, Mary Andrade, Mona Burtch, Joseph Cardoza, Fern Clark, Walter Correia, Phyllis Day, Miyeko Furusho, Shirley Gallegus, Angie Gallegus, Dona Hall, Kiyoto Ichisuka, Kumiko Ishida, Shirley Kraft, Tommy Masuda, Jimmy Nakamura, George Ohye, Morris Perry, Charlie Ramsell, Donald Silveria, Lillian Souza, and Agnes Troncoso.

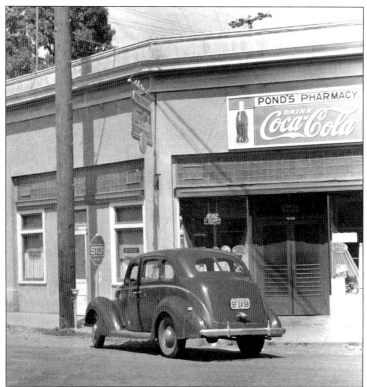

Dr. Judge Haley Durham set up practice in Irvington in August 1897, renting from the Corners druggist "Pa" Ford, and worked there for 57 years, using up to four cranked chairs. Dr. Durham had various assistants over the years, and in 1897, when Frank Chance was evaluating career options, he appears to have spent time in Dr. Durham's new office with the idea of entering the University of California.

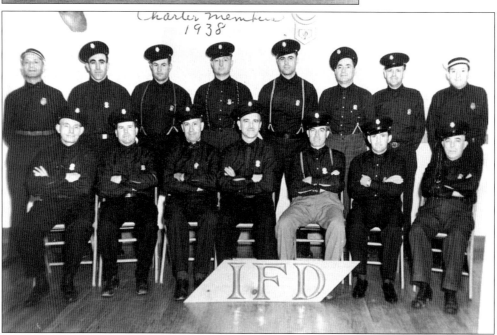

Irvington Fire Department and its charter volunteer firemen are photographed in 1938. Pictured, from left to right, are (first row) Ben Cramer, Bill Rose, Edward L. Rose, Joe Silveria, Leonard Freitas, Al Moniz, and Pete Medeiros; (second row) Joe Corey, Edward Harvey, Frank Brown, Wayne Day, Al Peixoto, 'Step' Raymond, Manuel Soto, and Bill Hirsch.

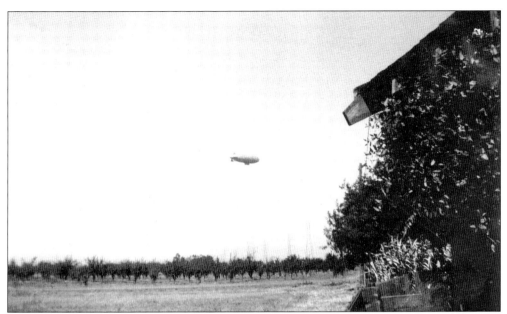

This blimp patrol photograph was taken January 28, 1942, on Osgood Avenue. Moffett Field became the home of research labs for the National Advisory Committee for Aeronautics (NACA), which expanded in 1939 and started three wind tunnels. With the United States' entry into World War II, research shifted to critical advances in deicing technology. The California coast was patrolled in 1942 by the blimp before a mysterious crash in August 1942. (Courtesy Inderbitzen family.)

Alberta Nunes shot a roll of film one day in 1942, documenting her friends and the changes underway in Irvington. Ed Rose, her boss, was moving his feed business from just east of the mortuary into the bottom of Clark Hall. Alberta and classmate Lavern Ferreira (in his new uniform) are in front of Reynolds store, with Pond's Pharmacy at far left. The door just to the right of the telephone pole (painted white to see in the dark) is where the switchboard operator worked. (Courtesy Alberta Nunes George.)

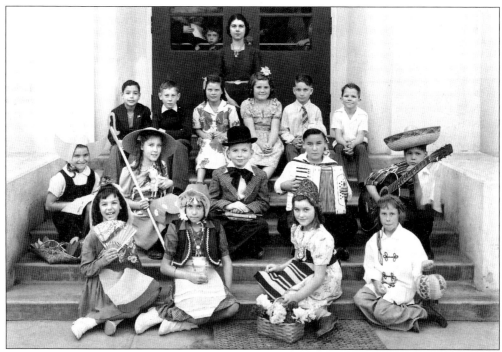

Irvington Grammar students, in international and nursery rhyme costumes, sit outside before a class play in the fall of 1942. There is an air-raid sticker posted inside the left door. The teacher was Carmelita Berge Freitas and the boy in the bowler hat is John Connolly. Irvington Grammar School lost many of its students in May 1942, when all families of Japanese descent were required to leave the community and live in internment camps.

The roller-skating team stands in front of the Maple Skating Rink, seen behind with the curved roofline. It was built by Otto Hirsch in 1907, after the earthquake, on what had been his grandparents homestead. The rink was also used for gatherings and dances on its beautifully sprung maple floor. To its left is Dinty's Tavern, behind the Costa Garage at the Corners. These properties developed in later decades as the Five Corners Shopping Center. (Courtesy Pat Schaffarzyk.)

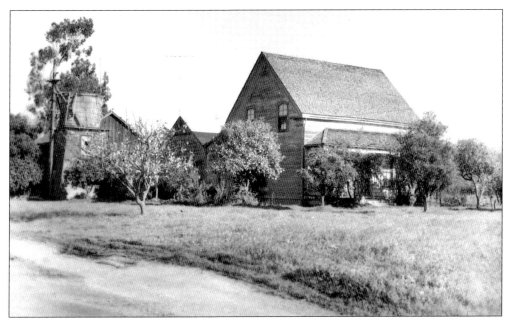

The Hiram Davis house and farm dates back to 1860. The Peixoto family lived there for two generations. In 1966, when this photograph was taken for the Fremont Historic Inventory, bachelor Isidore Peixoto lived there. Apricot trees still produced on the surrounding lands as the vineyards with Zinfandel grapes had long since been replaced. At right, the W. Y. Horner house could be easily seen across the tracks.

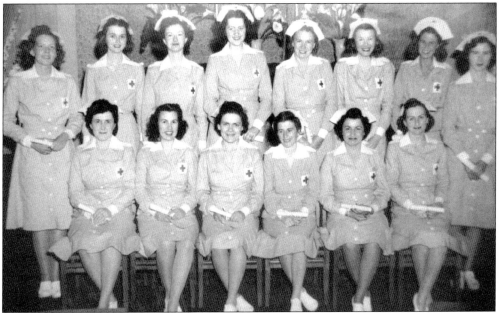

Irvington Red Cross ladies gather for a group picture in 1940. Gladys Williamson is fourth from the right in the second row; Mrs. Pond and Mrs. Fields are in the picture as well. They conducted training in first aid, organized blood drives, and prepared medical supplies. Gladys Williamson was Washington Township's reporter to the *Oakland Tribune* in the 1950s, and a key supporter in forming Fremont as a city.

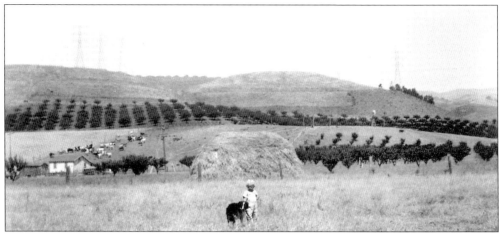

Frank Inderbitzen's son and dog are out in the fields at the south end of Durham Road, now Osgood. Hay was cropped between the rows of apricots and they kept a fine herd of milk cows. They moved a few years later to the Central Valley to expand the farm, as California was creating more regulations and standards, making a large-sized operation the only cost-effective way to continue in the dairy business. (Courtesy Inderbitzen family.)

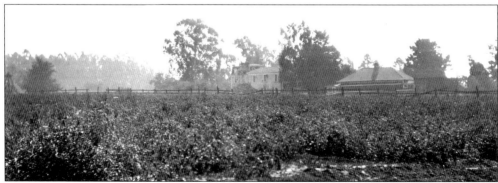

The sports fields of Washington College were planted with wine grapes by Bond in the 1930s. When Giles acquired the property for their racehorses after they were relocated by Camp Parks in 1942, they returned it to sporting use, this time for a horse-racing sulky track. (Photograph by Laura Thane Whipple.)

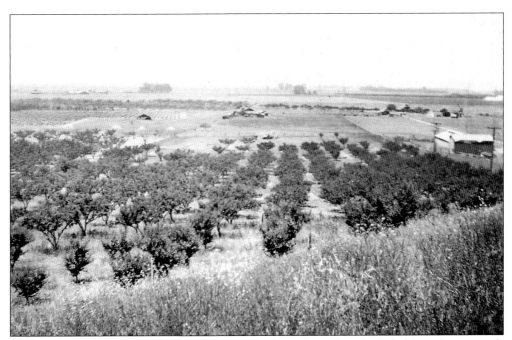

Looking the other way from the same hill position above Osgood on the Inderbitzen farm towards Mowry Landing, the Newark Substation and the shores of San Francisco Bay are. It is a wide-open landscape, with endless views over the "fruited plain." (Courtesy Inderbitzen family.)

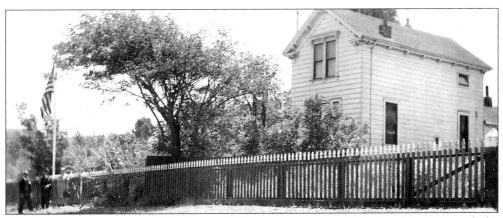

The Anderson estate sold the Washington College property to the Giles family in 1942, with the help of the real estate partnership of Otto Hirsch and Laura Thane Whipple. The Giles' property near Danville was needed for Camp Parks, a U.S. Army base. The campus buildings remaining were "Bonnie Brae" and the redwood gym. The Giles family brought a menagerie of animals, including the famous peacocks. (Photograph by Laura Thane Whipple.)

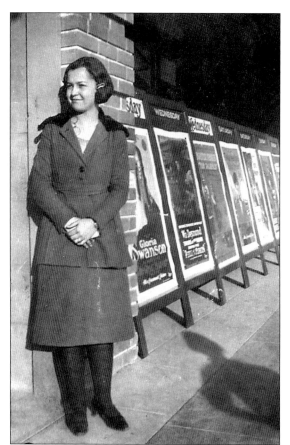

Ann Leal is outside the Leal Theater and its rack of lobby cards in 1942 when the theater was reopened. A Gloria Swanson movie was showing on Tuesday and *Bells of Heaven* on Wednesday. In 1947, Ed Simmons planned to buy it. However, he backed out and instead became co-writer for Dean Martin and Jerry Lewis with his cousin Norman Lear, and later earned several Emmys. (Courtesy Alberta Nunes George.)

The buildings on Bay Street front the sidewalk property line. Alson and George Clark commissioned Clark Hall, on the left, in 1876. This building is pictured below, *c.* 1942, when it was Edward Rose's feed store. It is the oldest brick building in Fremont and is on the site of the Walters home, the first tax assessor in the township. Bay Street Coffee and Broadway Theater now occupy the building and have brought new life to 4000 Bay Street for the past decade.

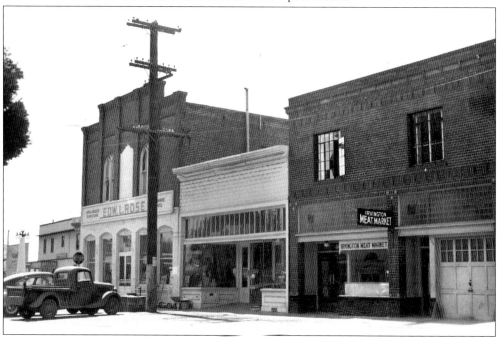

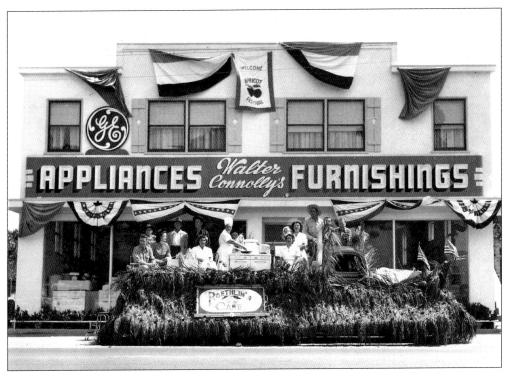

Roethlin's Café was a very popular spot next to Maple Hall. At the 1946 Apricot Festival, they partnered with Connolly's to carry the Occidental stove raffled off later in the day from their float. Walter Connolly was son-in-law to Mrs. E. H. Hirsch and ran the big General Electric dealership and furniture store, but found time to be chairman of the successful Sesquicentennial Parade Committee in 1947.

Otto Hirsch shows off the fruit in his orchard at the Hirsch-De Vaux ranch on Washington Boulevard. It could be the large Moorpark Apricot, which grew well in the area. (Photograph by Laura Thane Whipple.)

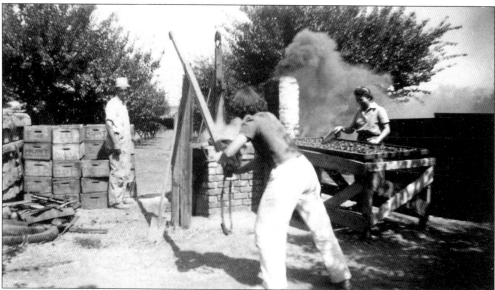

In a scene at the Tom Faria farm, Geraldine Bettencourt runs the hoist and Alberta Nunes spreads the dipped prunes out on the tray. Leland Cutler describes in his 1954 memoirs, "We rigged up a dryer and dried our own prunes. That meant a big cauldron for boiling water with lye added. A perforated bucket full of prunes was swung on a light derrick and dipped in the water. This perforated the skins to hasten drying and then the prunes were rolled out on a tray . . . I grew up to dislike prunes." (Courtesy Alberta Nunes George.)

Ed Harvey, at Ed Rose's Feed Store, fixes the feed sacks in their sturdy iron holder. With the majority of Irvington residents living on small farms, and at the very least having some chickens for their own use, there was always a regular flow of traffic into the store.

Strolling in front of the Irvington Inn, a pool hall next to the grocery, are store owner Billie Leal, Mena Silva, and Lorraine Garcia in 1944. The postal clerk worked right in the grocery store. Regular airmail began across the United States in 1934, when it was assigned to the Army Air Corps. To send letters by airmail one had to use extra-light airmail paper or buy special folding air letters at the post office.

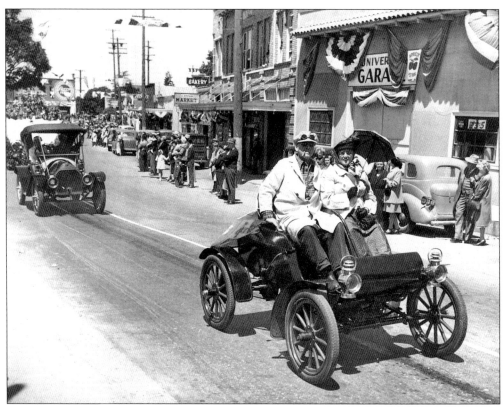

Mr. and Mrs. Charles Lee Tilden Jr., cousins of Laura Thane Whipple, came down from Berkeley for the Apricot Festival to show off their family's old electric car. Charles Tilden was a letterman in rugby at the University of California, Berkeley in 1914, the last year it was played instead of football. He was captain of the American rugby team at the 1920 Olympics, fielded with California players. They won the gold medal, beating France 8-0.

Three Swiss dairymen musicians stand in front of Roethlin's Café at the Apricot Festival on June 23, 1946. Pictured, from left to right, are Joe Schelburt, Carl Reichmuth, and Joe Studer. Instruments played on the Roethlin's float included string bass, trumpet, and accordions.

It isn't hard to see the Apricot Festival Parade excitement with many onlookers climbing all over the Irvington monument in the middle of the street. In 1944, Ed Rose purchased Clark Hall for his expanding business and his staff included Alberta Nunes, Lavern Ferreira, and Ed Harvey among many others. Farmers like Don Driscoll were regular customers. Clothes were still formal, when one might wear a suit to watch a parade. (Courtesy Alberta Nunes George.)

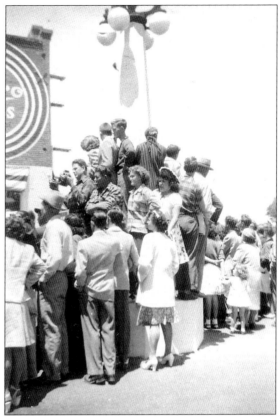

Fire chief Al Peixoto and a fellow volunteer firefighter drive through the apricot orchards on Roberts Avenue as the parade gets organized. Alfred Peixoto grew up in the Hiram Davis house with his brother Isidore, and worked for local butchers while still in high school. Al commissioned Randall Griffin in 1931 to build a two-story building with art deco details at 4004 Bay Street. (Courtesy Alberta Nunes George.)

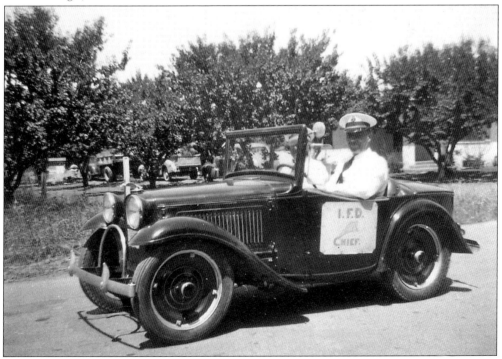

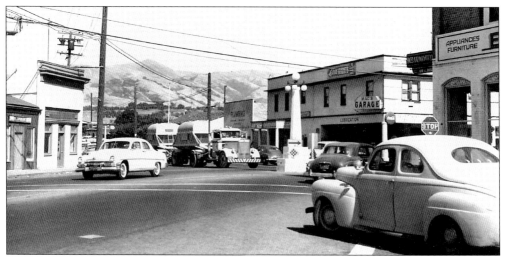

The Irvington interchange is the center of activity again and arrows point the way around the monument. The little building on the far left was Dr. Durham's office, which closed in 1954 after 57 years. Other gas stations in town included Frank and Josie Delgado's Chevron Station, opposite the Irvington School at the north entry, and Soito's Union Gas Station at the south entry next to the Maple Hall.

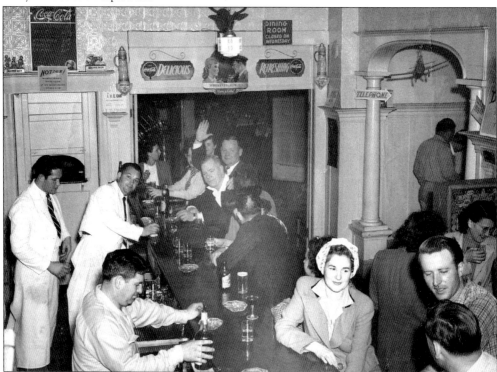

Tony Vilela's Playhaven, offering Italian dinners and dancing, was located on the Centerville-Irvington Road. Tony, the owner, is the man pouring at the cocktail bar. The trio in the right foreground includes, from left to right, Rosemary Ramsell, Wally Wipfli, and Gene Ramsell—all Irvington dairy people. After the Apricot Festival, people went to Tony's for the beef barbecue on the back lot. (Courtesy Pat Schaffarzyk.)

Five

SPACIOUS SKIES
1947–1964

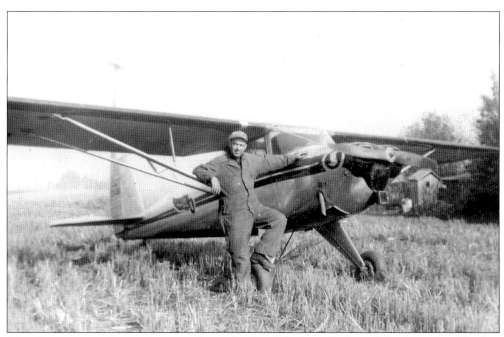

John Gomes is standing with a crop duster that landed where Durham School is today. The hay had already been cut and the stubble not yet burned, so it must be mid-summer in the early 1950s. John Gomes recorded the activities that happened on his ranch during the decade in a series of photographs. His grandparents, the Silvas, had farmed this ranch, between Driscoll and Stivers lagoon, since the 1870s. (Courtesy Diane Leys.)

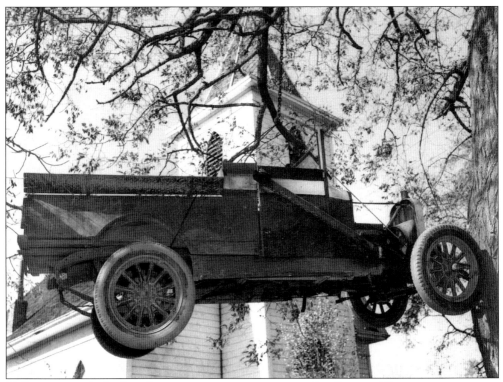

Halloween pranks by farm boys were once common near the Corners. The perpetrators were not recorded, though Dino Vournas of the *News Register* captured this photographic evidence of the suspended jalopy. The Christian Church was built on San Jose Road in 1886 and was enlarged with a steeple in 1939. The Monument Plaza Shopping Center is now in this vicinity. (Photograph by Dino Vournas.)

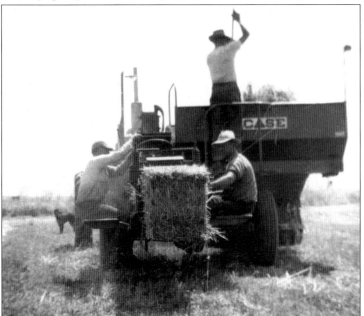

The new J. I. Case wire-tie, hay-baling machine was used at the Wipfli dairy ranch on Wipfli Road. Two people were needed on the back to operate the needle-block and wire-tie operations. It was a dry, dusty job that produced a blast of hot hay particles right into the worker's faces. Pictured, from left to right, are Wally Wipfli, Frank Wipfli (sitting), and Johnny Wipfli. (Courtesy Rose Wipfli.)

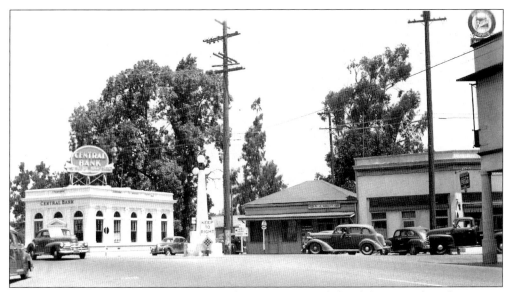

Irvington Corners, with the trees of the Mack estate grown up behind the Central Bank at Union Street, is shown shortly after the bank got its neon sign around 1950. The hipped-roofed building is the original Mack Store, which was moved in 1860 (with heavy animals such as oxen) on a wheel bed from Mowry Landing. The Mack Store would survive floods and numerous uses, but finally disappeared by 1990 in a wave of redevelopment and road widening by.

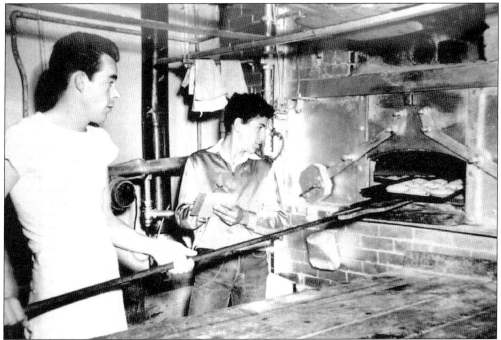

Baker Tony Delgado and a helper are at work at the Irvington Bakery in the Leal Building in 1948. They supplied everyone, including the famed Mayock gourmet events at the Los Amigos winery. Los Amigos was one of the first award-winning California wineries, when run by Robert Mayock from 1934 to 1945. He was California's first wine columnist. Souverain Cellars of Napa produced award-winning wines there until 1952.

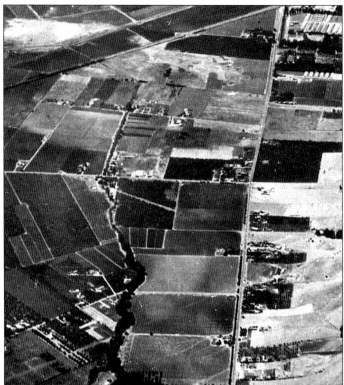

In this 1940s aerial view, Mission Creek drains north toward the lagoon and Stivers Slough in a thick, dark line. The straight road along the right side of the photograph is Mission Boulevard, and the straight road across the middle is Driscoll Road. Many of the dark fields are Driscoll strawberries. The Irvington Portal is to the right-hand side of the photograph, connecting to the Coast Range Tunnel of the Hetch Hetchy Aqueduct. Kimber Farms is at the top right corner.

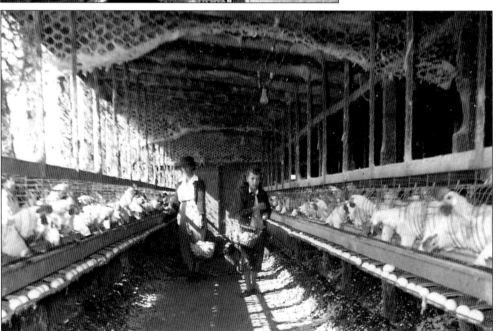

Mrs. Gomes and her daughter Diane ran the egg operation with 2,000 chickens in long chicken houses on the Gomes Ranch, north of Driscoll Road, one of several ranch enterprises. Diane Gomes became a teacher in the Fremont Unified School District as well as Gomes School, which was built on her family's former farmland. (Courtesy Diane Leys.)

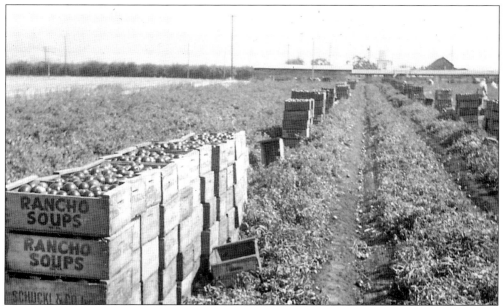

At a field on Gomes Ranch, tomatoes are being picked and crated under contract for Rancho Soups, an arm of Schuckl Cannery at Niles. The chicken houses, barn, and water tank are in the distance. Mission Valley took its name from the fertile fields that drain into Mission Creek and the lagoon, farmed for wheat by the "first farmer of California," John Horner, from 1847 to 1874, and by the mission from about 1800 until the 1830s. (Courtesy Diane Leys.)

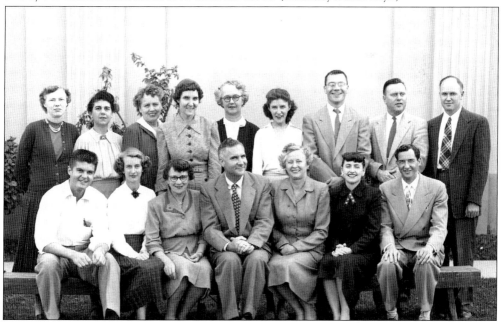

The teaching staff poses at Irvington Grammar School in 1952. Pictured, from left to right, are (first row) James Anderson, Darlene Greb, Mary Bailey, principal Gus Robertson, Stella Benbow, Diane Minto, and Glen Tremayne; (second row) Verna Silva, Carmelita Freitas, Marcella Stivers, Neva Pennington, Irma Bond, Marion O'Flaherty, Richard Hammer, Bernard Cullery, and Llewellyn Gordon.

The Durham family is photographed in 1946 at the old Christian Church. Pictured, from left to right, are Mabel Durham, Mildred Durham Foster, Ken Foster, and Dr. Judge Haley Durham. This same year Frank Chance was elected by his peers to the National Baseball Hall of Fame and is the only player/manager to ever play in four World Series, winning with the Chicago Cubs in 1907 and 1908. (Photograph by Foster's Photograph Service.)

This 1950 aerial view was taken over the Durham Ranch (the dark rectangle in the bottom left). To the east side of the road and stretching up the hill are the light-colored sands and gravels of the Bell Quarry. Just north of the quarry is the McCullough farmhouse and old orchard, where the Durhams lived for 25 years. The oldest son graduated from Washington College and the youngest from Anderson Academy. (Courtesy Durham Collection.)

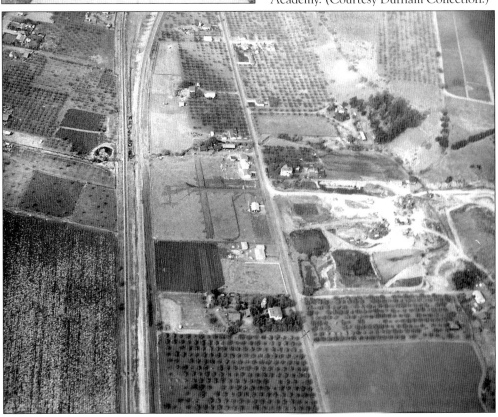

The rock sorting and crushing plant at the Bell Quarry was a sign of progress, producing large-scale orders of rock and sand for roads and other construction. Originally, the Osgood Quarry was just extraction, and crushing was not added until around 1950 by the Bells. Contracts for highway construction required strict testing standards for fines (coarse sands) up to one-and-a-half-inch gravels. (Courtesy Durham Collection.)

This is a shady drive along the side of the Durham house leading to the barns and sheds behind. The various species of trees include the Canary Island palm and the Chilean pepper. They still stand, as does the house. The garden dates back to 1889, when Rev. J. D. Durham purchased the farm. The garden included Mediterranean plants such as olive, fig, palm, and citrus, and every fruit possible in the orchard, for both practical and poetic reasons. (Courtesy Durham Collection.)

Robert "Bob" Kithcart was manager of the first branch of the Bank of America in Irvington from 1957 to 1966. He settled in Irvington with his family and was part of local civic life, including being vice-chair of the 1964 Fremont Capital Improvements Finance Committee. This picture was for a roast that celebrated his career in 1987. The bank is one of the few original tenants left in the Fremont Shopping Center at Grimmer and Fremont Boulevard. (Courtesy Mrs. R. Kithcart.)

The Rancadore family travel up for the weekend from San Jose in their Cadillac to their Uncle Mike's hunting lodge on the outskirts of Irvington. The lodge was down past the military airfield (that later became the drag strip) and the Newark substation. There was a stable and a hunting-dog kennel, as well as duck ponds beyond the lodge. The family was second generation in the San Jose Cannery business. Pictured, from left to right, are Sal, Constance, and Tommy Rancadore. (Courtesy Connie Rancadore.)

The tiny "wedding cake" bank, designed in 1910 by Henry Haight Meyers as the Bank of Alvarado, had changed its name to the Bank of Alameda County by the time it was built (see page 91). Meyers himself later became architect for the County of Alameda. The bank was absorbed by the Central Bank in 1938 and closed in 1958. Thereafter it became the first home of the Fremont Chamber of Commerce. Pictured are Central Bank manager Carl Christensen (left) and Dr. J. D. Durham.

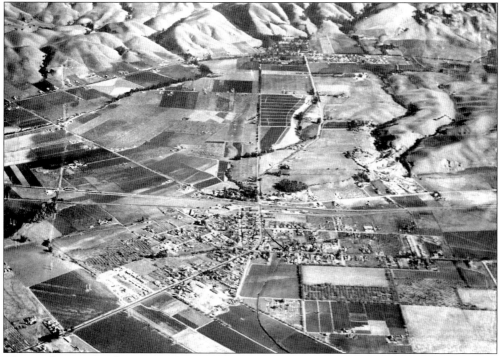

The Washington College grounds stayed intact as the Giles estate (Peacock Hill) for decades, narrowly escaping eminent domain in 1966. In the 1980s, the 1871 campus became a housing project, retaining several heritage trees. Listen carefully in those old trees and the crack of a hickory bat, whisperings of Latin and Greek declensions, or a faint cornet playing at sunrise may be heard; perhaps the spirit of those halcyon student years lives on.

In 1946, James "Ralph" Baxter and Jim Campbell started the Irvington Packing Company, with its distinctive triangle label. Cooper Fernando Lopez produced redwood vats 12 to 15 feet across that could hold 10 to 20 tons of sweet pickles. Four years later, they moved into a concrete block building by Randall Griffin on Durham Road, on Western Pacific property. The Irvington Packing Company had a dozen employees, and depending on what was ripe, could pickle cucumber, cauliflower, and peppers. The partners sold the business to the California Conserve Company in 1960 and it changed to packing relish. In 1975, the vats were taken apart for the wood. Even now, when the humidity is just right, wherever that wood has been reused, the smell of sweet pickles still wafts through the air.

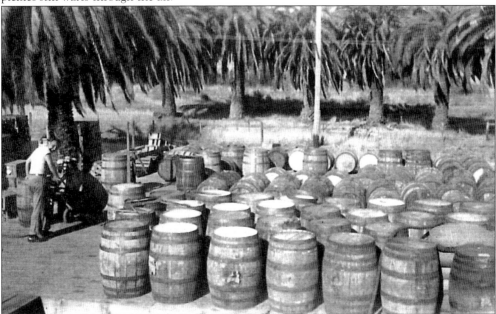

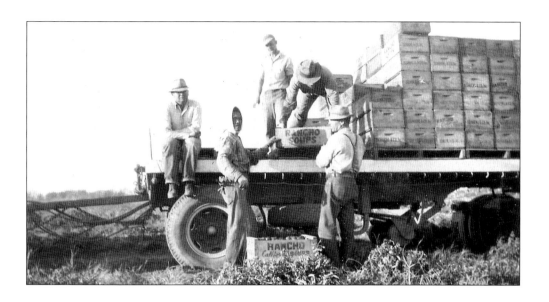

In the 1956 directory, produced by the new Fremont Chamber of Commerce, there were many fruit and vegetable growers, shippers, and packers in Irvington. These included A. E. Alameda, L. E. Bailey, J. Fudenna, Pacific Fruit and Produce, and W. Burdette Williams. Williams was known for its huge packinghouses near the railroad depot, where they served for a variety of producers. During World War II, they could move the equivalent of 5,000 crates or 11 carloads of fresh vegetables in three days to supply military contracts. Some growers sold directly to canners such as the San Jose Cannery or Del Monte, packing the crates with ice for the trip. Arnold Papazian grew up in the produce-brokering business in San Francisco. As a young man, he farmed his own lettuce, celery, cabbage, and strawberries in Irvington, marketing to wholesalers in San Francisco and Oakland for several years until he left to serve in the Korean War. In 1958, he established Papazian Distributing Company in Salinas, which later became Titan Procurement. Above are crates packed at Gomes Ranch, and below are the Irvington warehouses, next to the Irvington rail depot.

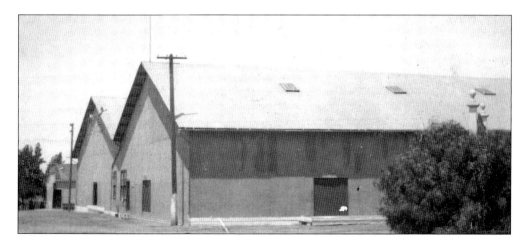

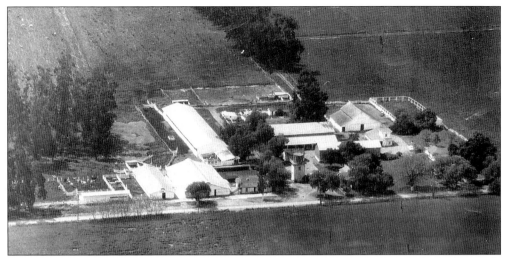

Mowry Landing Dairy is seen here in the 1940s, before it was sold to Willis Brinker. The Wipfli Brothers Dairy (1917) also sold after 40 years. To quote the auction poster, "460 milk cows, many Fresh and Springers. Includes 160 first calf 3 yr. old Heifers, and Springers now freshening. . . . Go one mile West of Irvington. West of Highway 17. P.G.E. Road at Cook Road. Watch for blue flags and arrows." (Courtesy Rose Wipfli.)

The board of trustees of the Washington Union High School District was photographed by the *Oakland Tribune* in 1961 at Blacow and Grimmer Boulevards. The occasion was the beginning of Irvington High School, the first new high school in southern Alameda County since Washington Union High School in 1892. Chuck Grimmer, clerk of the board, is third from the left.

United Nations Day is celebrated with a shovel on October 24, 1959, at Irvington Park, 15 years after the United Nations charter had been drawn up in San Francisco. Pictured, from left to right, are Dr. Edmond Kaiser, Mrs. Laura Thane Whipple, Stan Silva, and Mayor Michael Overacker. The previous year, on United Nations Day, a bit of land at Olive Avenue and Washington Boulevard was proclaimed United Nations Plaza; Peace roses are thought to have been planted.

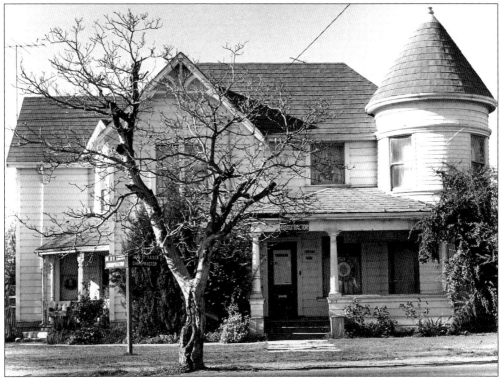

The Babb Cronin Kaiser house, at the intersection of Fremont Boulevard and Carol Avenue, is known for its conical tower roof. Nathanial Babb, a pioneer in 1852, was postmaster and a merchant. Dr. Kaiser hung his business sign outside for many years. The house was refurbished between 1998 and 2004 by Warren Darmsted, a Hayward police detective who loved to fix up Victorian homes. (Photograph by Julianne McDonald Howe.)

This is a faux bois (false wood) gateway by a concrete artist from France, created during the glory years of the Los Amigos Vineyard under Grau and Werner, and photographed during the Mayock era (1934 to 1947). The winery estate entrance on Washington Boulevard was near Meredith. The vineyards extended back and sloped down the valley, which had been planted with resistant rootstock from France before World War I. The gateway lost out to road widening in 2004, but the winery's palm trees survive in the median.

Life magazine sent photographer N. R. Farbman to Irvington in 1945 to record the "boy paleontologists" and their adviser, Wesley Dexter Gordon, at work in the Bell Quarry. The *Life* photographers are the two people on the far left, and some of the boy paleontologists are to the right. They appear in the same issue as the Nuremberg Trials of late 1945. During his career, Farbman photographed scenes as diverse as Pearl Harbor and space travel. (Courtesy Gordon family.)

The stepped walls of the Bell Quarry, at right, give no clue of the massive ice-age fossils found embedded in them. The Pleistocene fossils found at Irvington were so unique that the era they marked was named the Irvingtonian Era, and the new type of pronghorn deer was named Tetrameryx Irvingtonensis. The 1946 photograph below is Donald Elvin Savage with his professor, uncovering a mammoth find, and Mission Peak is in the distance. Since 1951, the "distinctly bedded cobble conglomerate, gray conglomeratic sandstone, and gray, coarse-grained, cross-bedded sandstone" gravels are referred to as the "Irvington gravels of Savage." Don Savage (1917–1999) became Professor Emeritus of Paleontology at the University of California, Berkeley and a specialist in biostratigraphy, a fossil-dating method developed before radioisotope dating became easily available. Savage was the driving force that made the university's museum of paleontology a renowned international resource. (Courtesy Gordon family.)

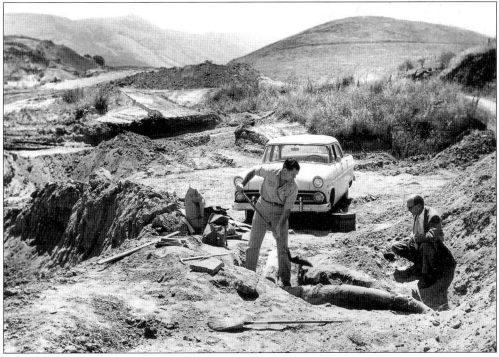

Pat Wasko was chosen in 1960 as Miss Fremont Center. The stores there included Cloverleaf Bowl, Fremont Drugs, Higgins Auto Supply, Mae's Fashions, Todd's Shoes, Beauty Manor, Sam's Barber Shop, Family Shoe Repair, House of Pizza, Launderette, Coronet Cleaners, Rogers Variety, P-X Market, Tidewater Flying "A", Bank of America, Smith's Fabrics, and the All-Jersey Milk Depot. (Photograph by Bruce Chin, Lux Studios.)

A Cloverleaf Bowl promotion has the manager posing with the "Maid of Fremont" and a friend during an expansion in 1974. Established in 1959, Cloverleaf Bowl was acquired by the Hillman family in 1963 and was enlarged by 12 lanes. It included a restaurant, nightclub, and baby crèche when it first opened. This was the place to hear live music, including the young Ink Spots. (Courtesy Hillman family.)

Mr. and Mrs. Hillman show off the latest in bowling record-keeping technology in 1963. It was the year that the Cloverleaf became famous for its 65¢ broiled hamburger on a toasted, sesame-seed bun that made it locally famous (a larger "Bowler Burger cost $1). Another favorite was the fabulous goblet hot fudge sundae for 70¢, with slivered almonds, gobs of whipped cream, and a cherry. (Courtesy Hillman family.)

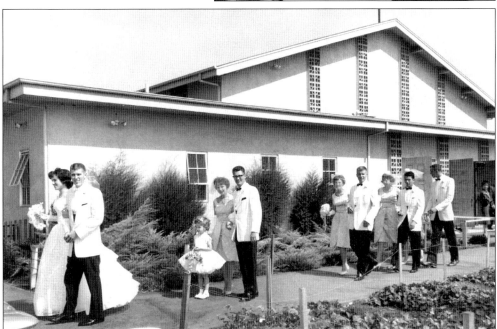

The Maloney wedding was held September 23, 1962, at St. Leonard's Church. The bridal party, pictured here from left to right, consisted of Willene and Cliff Seavey, flower girl Dodie Currie, maid-of-honor Bobbie Carpenter and best man Dan Bettencourt, Jaunette Bass, Don Arrington, Barbara Lang, Bob Souza, Debbie Jurickovich, and Dennis Maloney. The new church was built on Copeland land purchased from the bride's family. (Courtesy Earlene Walker.)

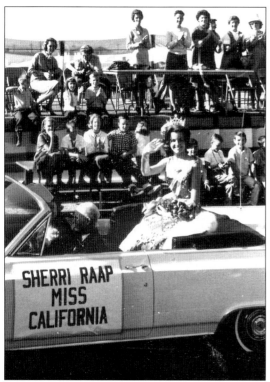

The grand marshal of the 1964 Pathfinders Parade was Miss California, Sherri Lee Raap, a finalist in the Miss America competition later that year. She graduated from Washington High School in 1963, the year she won the Miss Fremont contest. A student pilot at the time, after winning the California competition in Santa Cruz, she flew back to the Doolittle Air Terminal at Oakland in a Piper Cherokee made available for her reign by Comstock Aviation. (Courtesy Don Dillon.)

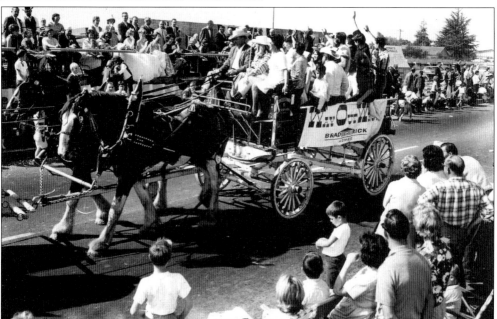

Way Out West was a Brad Rick Homes subdivision on the east side of Central Park under construction in 1964. Lake Elizabeth was being graded down into the clay layers in 1967, and stream flows were being diverted around the future lake and flood-control facility. Cheryl Cook-Kallio, who grew up in Way Out West, amazed her Irvington High School students when she told them she walked across Lake Elizabeth when she was growing up. (Courtesy Don Dillon.)

Six

IRVINGTON PLACES
1965–2005

A couple goes for an evening stroll on the new Lake Elizabeth wharf in 1969. The silhouettes are reminiscent of the Beatles's *Abbey Road* album cover of the same year. The City of Elizabeth in Australia also contains a large picturesque lake with extensive tree planting and is a favored place for citizenship ceremonies—it is named Fremont Park. Fremont and Elizabeth both incorporated in 1955 and were sister cities for many years. (Photograph by Dino Vournas.)

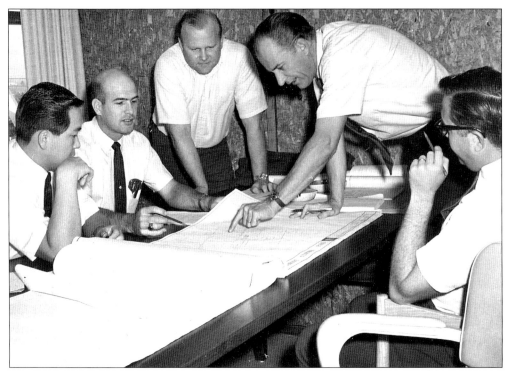

The last staff meeting of the Recreation and Leisure Services Department in the old city hall was held in December 1968 in Stuart McCormick's office. Under the lead of parks superintendent Harpainter, they are reviewing contract drawings for Central Park, which was designed in-house. Pictured, from left to right, are Lincoln Fong, Richard Pool, Stuart McCormick, Ted Harpainter, and Lorn Turk.

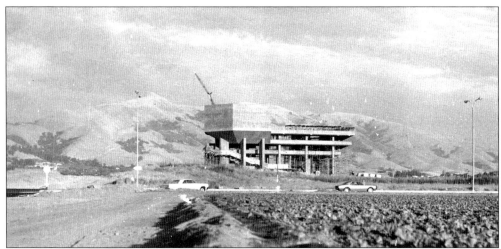

The Central Park design set the stage and counterpoint for the dramatic bulk of the Corbusier-influenced city government building. Abstract expressionism was the fashion of the day, and Bay Area visionaries such as William Penn Mott Jr., Oakland's parks superintendent, were writing about the "city in the park." Over 400 acres was a large area to be transformed in 1969, and it was decades before the park actually grew to its intended size. In 2004, it was named Best Park for the Tri-Cities area by *Argus* newspapers.

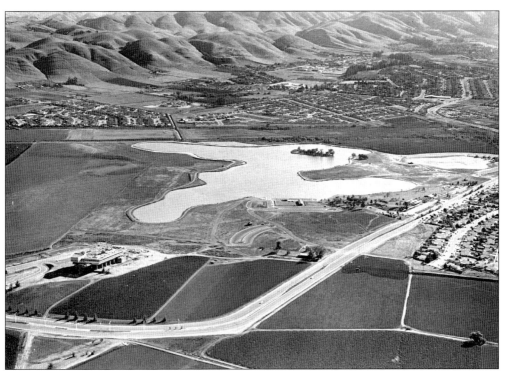

Theodore "Ted" Harpainter graduated with a degree in landscape architecture from the University of California, Berkeley in 1950. He was hired to develop parks for the City of Fremont in 1959. A gifted painter, he retired at a young age in 1979 and moved his studio to San Luis Obispo County, where he still paints today. Lake Elizabeth might be a lobed leaf-shape by Matisse, set off by Ted's dramatic double allée of poplars, wind-tossed daily as in a Van Gogh painting and silhouetted against Mission Peak.

Architect Bob Mittelstadt of San Francisco gazes up at his first big commission in the fall of 1968. He won the international competition for a city government building with his essay on brutalist concrete. The original design even had sailboats making their way up to the building. He is recording the construction progress with a home movie camera. The long office wall on massive stilts paid direct homage to the 1957 Corbusier design, the *Friary of La Tourette* of Lyon, France.

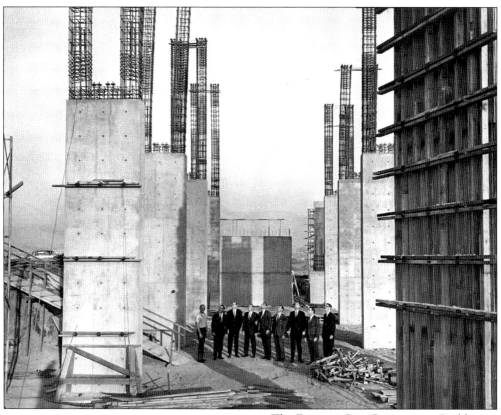

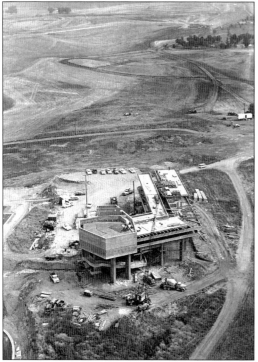

The Fremont City Government Building was distinctive, with its massive council chamber at its north end, held up by monumental reinforced concrete pillars above the park knoll that supported the entire enterprise. Steve Rubiolo of the *News Register* caught this dramatic shot of the city council and key project players looking up to where that chamber was soon to be built in September 1967. Pictured, from left to right, are Don Jamison, Hugh Block, Geoffrey Steel, Don Dillon, Gene Rhodes, Bill van Doorn, Don Driggs, Garth Lipisky, and John Goss. To the south of the city government building lay the dry outline of the future Lake Elizabeth. Construction of the lake was a shared project with Alameda County Flood Control District, as it was planned as part of a long-term strategic plan for flood control. The lake was enlarged on its east perimeter in the early 1990s to further these goals, and the curve of this shoreline is more engineered and less dramatic than the earlier-designed parts of it.

The first time the American flag and California Flag (10 feet by 15 feet) flew over the Fremont City Government Building was March 24, 1969. The wind could really funnel under the structure and the halyard clanged noisily without pause. The state flag design is associated with the Bear Flag Uprising in 1846 in the town of Sonoma. Pictured, from left to right, are Florence Smith, Ralph Nenes, and Dee Schaffner. (Photograph by Dave Breninger.)

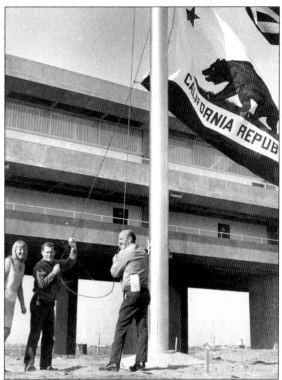

The original Puerto Penasco Swim Lagoon had its opening event in 1969. It was named for Fremont's sister city in the Mexican province of Sonora, which is known for its beaches. White sand was brought from Monterey to build the circular beach for the swim lagoon in Fremont, and it would be refreshed over the years. The lagoon was the place to go in the summer where lots of lifeguards were on duty.

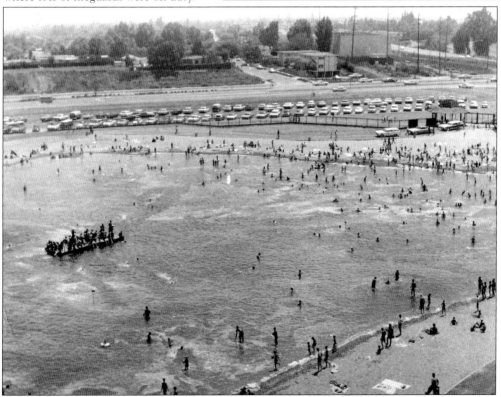

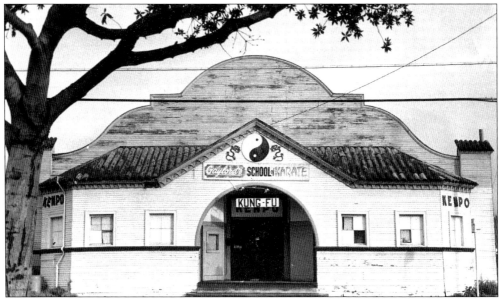

Maple Hall, or Maple Rink as it was known, was no longer needed in Irvington as a place for the community to gather and skate. Its façade announces it as the home for Gaylord's School of Karate. It thrived here for many years until the Five Corners Shopping Center development led to replacing all the buildings in the vicinity of the "Old Corners."

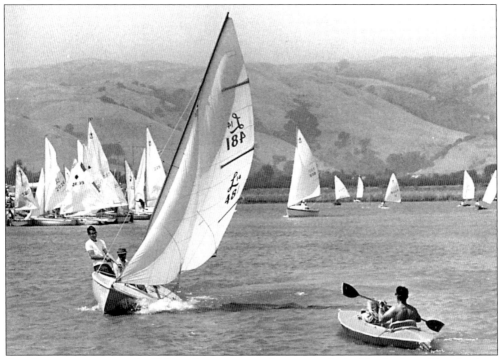

Another new activity at the 1969 park opening was boating on Lake Elizabeth, and local sailing enthusiasts organized a regatta that day. Boating activity on the lake was always dependent on the ability of the park ranger's staff to maintain a safety boat patrol. At sunset, it was also their task to round up any paddleboats that might have gotten waylaid on the far side of Bird Island.

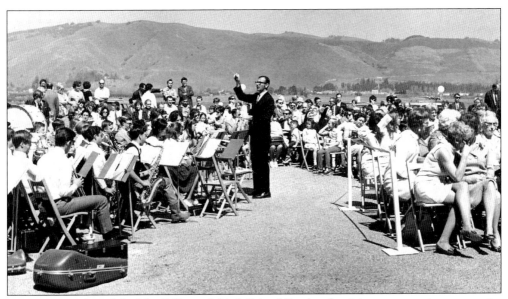

Don Kruse conducted the John F. Kennedy High School Band at the civic center opening ceremonies in 1969. He taught at the school from 1967 to 1982, before a year at Washington High School and a stint as director of bands at London Central High School in England. This award-winning conductor retired from Hopkins Junior High in 2000, but was brought back in 2005 to conduct the annual Honor Bands in Concert for the Fremont Unified School District.

These Fudenna-brand "Fanciful" cauliflowers were packed at the Fudenna packinghouses south of Irvington. The family has farmed near Irvington since the early 1900s. The Fudennas donated land at the northwestern corner of Central Park, and the City of Fremont purchased an adjoining parcel of their land. The Parkway Golf Course and Bill Owens's Brewpub on the Green (1987 to 1994), one of the first brewpubs in the country, were also on Fudenna farmland. The family is still in business today from their offices on Paseo Padre Parkway.

The headless horseman was a unique entry in the 1976 Pathfinders Parade. "On mounting the rising ground, which brought the figure of his fellow-traveler in relief against the sky, gigantic in height, and muffled in a cloak, Ichabod was horror struck, on perceiving that he was headless!" This quote was found among the papers of the late Diedrich Knickerbocker, found by Washington Irving and first published in 1820 in *Three Tales from the Sketch Book of Geoffrey Crayon, Gent.* (Courtesy Don Dillon.)

These visitors to Pathfinder Days recall another tale. In 1905, Leland Cutler and a fellow Stanford student took pictures of monkeys from a circus near San Jose picking up pebbles and looking intently at the ground. Cutler then wrote a story about "a farmer in the Santa Clara Valley, who, owing to the shortage of labor, was training monkeys to pick his prunes . . . we had good pictures to prove it and syndicated the story through San Francisco to the east." (Cutler, 1954, photograph by Dino Vournas.)

Irvington High School entered the first Pathfinders Parade in 1964 with a bold Viking longboat. The school makes the most of its Viking traditions by taking loving care of its Valhalla Theater, a Saga yearbook, a *Rune* literary magazine, and a community newsletter called the *Viking Explorer*. The school won the California Distinguished School Award in 1994, 1999, and 2005. (Courtesy Don Dillon.)

A rock concert highlighted the 1970 Pathfinder Days as John Mayall was on tour with Larry Taylor, Harvey Mandel, Sugarcane Harris and Paul Lagos—his Bluesbreakers lineup that year. The fences around the dry swim lagoon were rushed, as the audience was not prepared to pay the $20 entrance. Later that year Mayall recorded in London with former protégés Eric Clapton and Mick Taylor. In 2005, Mayall was awarded the OBE (Order of the British Empire). (Courtesy Don Dillon.)

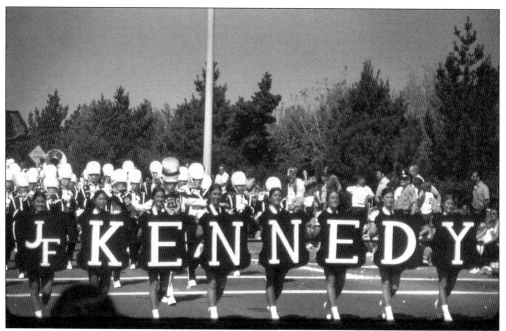

Kennedy High School was an award-winning marching band in the parade years under Dan Kruse and precision marching was their particular trademark. One of the secrets was measuring how high each person's foot should go, so everybody landed at the same time. The drum major is behind the majorettes. By hosting the Pathfinder Parades between 1964 and 1978, Fremont provided its many (mostly new) high schools with a place to show off their expertise and bravura. (Courtesy Don Dillon.)

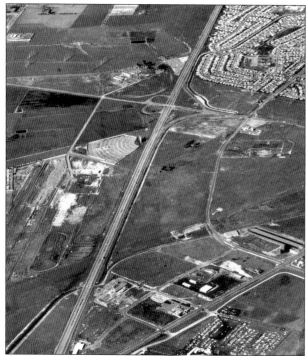

This aerial view was taken in 1968, just north of the 1961 General Motors plant. The fan shape to the left center was the Irvington Drive-in Theater, owned by Robert Lippert, the producer of one of the first science fiction movies, *Rocketship XM.* Below that is the defunct Army Air Corps Airfield from World War II, reborn in 1958 as the glider airport, and the quarter-mile Fremont Raceway. This well-used drag strip became Baylands Raceway Park in 1981.

By 1975, Mike Bagnod was managing the Fremont Raceway. On a weekend night there might be 100 serious drivers out for grudge racing, two at a time, waiting their turn at the pre-staging lights. From 1960 to 1966, the annual West Coast Championships were held there, when Ken Lawrence was strip manager. AHRA and NHRA events set records here and Lucasfilm used it for stock-car racing scenes in its 1979 sequel *More American Graffiti*, filmed after the first *Star Wars*.

Baylands Raceway Park operated every weekend throughout the year, with the gates opening at 5 p.m. for the night-racing show and at noon on Sundays. The track's best-known voice was that of Dave Vodden, announcer and marketing director, who is now with Thunderhill Raceway Park. In 1988, the park had a regular 30-lap, 20-car event featured on the three-eighths-of-a-mile oval and events such as the California Golden State Championship series for sprint cars, as well as the "King of California" and "fender bending family fun."

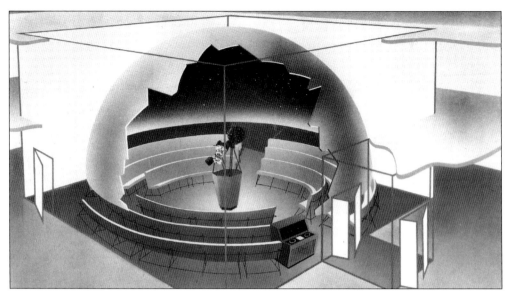

The 1965–1966 public educational lecture series at the planetarium at Hopkins Junior High School on Driscoll Road offered views from any point on the earth, as well as many points beyond. The federally funded planetarium had its own full-time staff in the post-Sputnik era of "new math and new science." The brochure stated, "Days and nights are compressed into minutes allowing for observation of visual features of the universe at the press of a button."

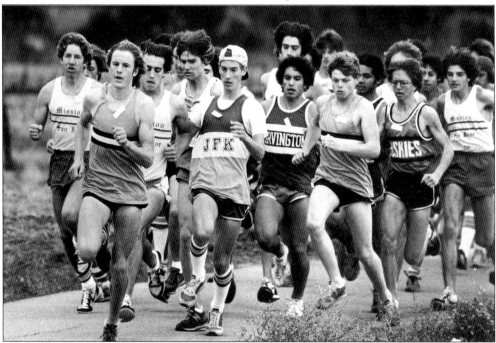

The high schools of Fremont Unified School District take each other on in a marathon around 1970. The Fremont Unified School District of 1964 inherited several districts: Warm Springs, Irvington, Niles, Alviso and Centerville, and most of the Washington Union High School District as well. Mowry Landing and Mission San Jose had already been merged into the Irvington School District in 1939 and 1959, respectively.

John F. Kennedy High School takes pride in its sports program. Basketball stars such as Lamond Murray (1992) graduated from Kennedy. Head coach and athletic director Pete Michaletos has been with the Kennedy Titans since 1964. He was quoted in *What's Happening* magazine in November 2001, "Love who you teach, not what you teach. The impact is that you are helping people who, in turn, will want to help someone else down the line."

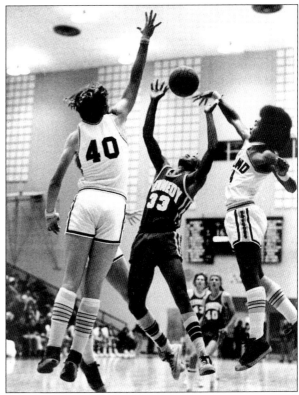

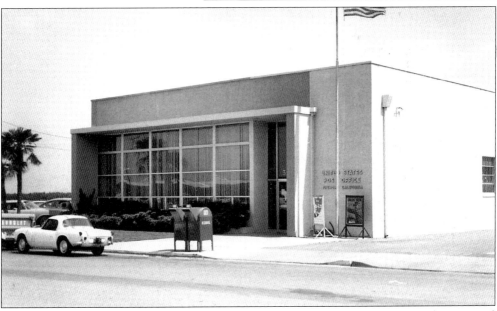

The Irvington Post Office had a peripatetic existence for decades, metamorphosing from general store to grocery store over the years, wherever there was space and customers. In 1967, it moved from its quarters in the Rick Mark Shopping Center into what may be the first federal government building in the Irvington area. Naval recruiting poster stands are positioned at the base of the flagpole and are a reminder of the Vietnam War.

Stevenson Boulevard was built next to Central Park after the park opened. It had the first night-lit sports field in Fremont. Washington Township Baseball was formed in 1954 in Irvington and is headquartered today on the baseball fields south of the Irvington Community Center, the former racecourse of the Nutwood Stables. Now Fremont Baseball Incorporated is the oldest youth baseball program in this part of the Bay Area.

Dominic Dutra shoots for the Vikings at Irvington in the late 1970s. In 2002, this Irvington and Santa Clara alumnus was elected to the Fremont City Council, and in 2004 he was honored as Ohlone College's outstanding alumnus. The public service tradition was begun by his father, John Dutra, who was elected to Fremont City Council in 1986 and to the California State Assembly in 1998 and 2001. (Courtesy Bernice Dutra.)

The Connolly family plans the first of many expansions of its furnishings business over the years with the Connolly Center. This photograph suggests that the Connollys certainly approve. They are still in business on the same site today, maintaining a long family tradition. Pictured, from left to right, are John, Mike, and Steve Connolly.

Kimberley Stathers prepares to go down on what she called the "biggest slide in the whole wide world" in December 1989. The J. F. K. Children's Play Area in Central Park was dedicated in January 1966 for Fremont's 10th anniversary and sponsored by the Brooks-Matthew Foundation, the Fremont Jaycees and Kiwanis, the Fremont Jr. Women's Club, and other citizens. The log playground was replaced in the 1990s. (Courtesy Jill Singleton.)

Pitcher Jim Pena sailboards on Lake Elizabeth in 1983. He played in the San Francisco Giants minor-league system, and was called up by the Giants in 1992 before being traded to the San Diego Padres. On the way to the boat launch, visitors can search on the right for a rare planting of Angophora costata, the Sydney red gum from Australia. (Photograph by Dino Vournas.)

Pictured here in 1983, upstairs at Clark Hall is newly restored, with light streaming through the gothic window façade. The original lightbulb still worked, having been little used since 1906. The last scenery backdrop was still in place, as were the countless signatures on the walls from former theater and dance troupes. Dr. Robert B. Fisher had his retirement party here in 1983, as the building had survived a road-widening project due to his hard work.

Horseshoes in the pavement in front of the Mattos blacksmith shop were embedded around 1910 on the 3900 block of Washington Boulevard, making the surface a lot more interesting to walk on. These horseshoes were very worn before being consigned to be part of the pavement; they may have been all over the township. They finally went to horseshoe heaven when redevelopment work replaced them in the 1990s. (Courtesy Phil Holmes.)

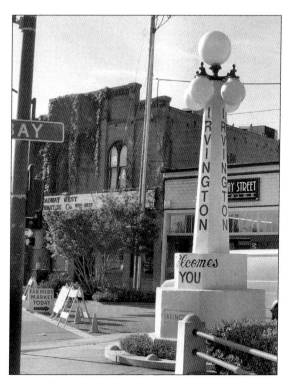

The Irvington monument returned to Irvington in 1978, before much redevelopment work began. The Clark Hall behind is home to Bay Street Coffee on the first level and Broadway West Theater Company upstairs. In 1978, Bay Street was still a through street to the right of the plaza, home to another Irvington treasure, Pearl's Café. Newark grads Chef Christine Fahey and Andie Ferman took over this fine Fremont icon in 2002. (Courtesy David Munn.)

123

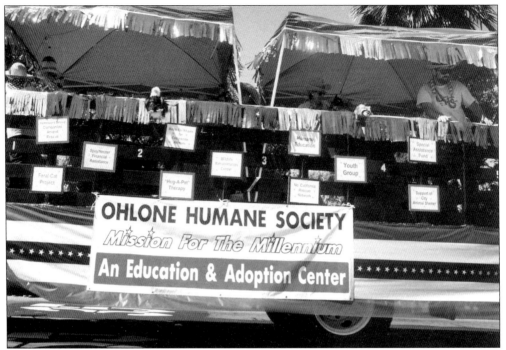

The Ohlone Humane Society entered the Fourth of July parade in Irvington in 2000 with this float. The society has cared for animals from the Tri-City Animal Shelter for over two decades. Its home is behind 2000 Stevenson Boulevard, which is the Fremont Police facility, designed by Leach Mounce Architects in 1999. As a result of this project, the northern boundary of Central Park finally received sidewalks. (Courtesy David Munn.)

Alan James Campbell, RMC, who served on the USS *North Carolina* in World War II, was honored in the Independence Day Parade in 2000. In 1986, Fremont hosted the Alameda County Veteran's Day Parade on Paseo Padre Parkway with the viewing stand in front of the Mission View Community Center in Central Park. Irvington will host Fremont's Independence Day Parade again in 2006. (Photograph by Margaret Thornberry, courtesy Dorsi Diaz.)

Caravana Mexicana volunteers work on a playground project in Puerto Penasco, Fremont's sister city in Mexico. Pictured, from left to right, are Melissa Casas, Cindy Tsai, and Hain Rahman. Caravana tree and pumpkin sales were held near the swim lagoon in Central Park until 2002. The teamwork projects of building, planting, and painting were undertaken in Puerto Penasco over spring break with 50 to 100 student volunteers. (Courtesy Cindy Tsai.)

These students from Irvington, Mission San Jose, and Washington High Schools formed the youth board for the 2003 Caravana Mexicana project. Pictured, from left to right, are (first row) Tina Laungani, Jessica Chou, and Jen Leidigh; (second row) Kim Stathers, Hirsh Jain, Chelsea Schick, Mariana Olvera, and Josh Cohen. The award-winning Caravana program was under the leadership of Ro Oliviera for 40 years. (Courtesy Mariana Olvera.)

The city government building had a special "Chip Off the Old Block" ceremony on the day demolition officially started in September 2004. The structure had long been paid for, but the city government was ready to move on from its flagship building as a result of seismic studies. Pictured, from left to right, are Dominic Dutra, Bill Pease, Steve Cho, Bob Wasserman, and Mayor Gus Morrison. The plaque installed at the dedication of the building on March 29, 1969, quoted from the Declaration of Independence. (Courtesy Jill Singleton.)

These vintage cars returned to Irvington in 2000, heading south on the 40,000 block of Fremont Boulevard. The planting of Washington palms was one of the most easily appreciated streetscape improvements among Irvington's redevelopment projects of the 1990s. The Washington palm is native to California and has been planted in Irvington since the 1880s.

The Irvington gateway signs were designed by Michael Manwaring, constructed by Englund and Donnelly in 1994, and are located at the three entry roads into the heart of Irvington on Washington Boulevard and at both ends of Fremont Boulevard. The signs are stainless steel and internally lit with neon. This photograph was taken on Fremont Boulevard near Blacow Road (formerly Cook Avenue). (Courtesy Phil Holmes.)

The Irvington High School team, "We the People," was California champion of the U.S. Constitution competition in 2005. Pictured, from left to right, are (first row) H. Sarker, V. Tang, M. Choi, N. Sanders, J. Dequinia, M. Siew, R. Joshi, T. Schrodetzki, and S. Musto; (second row) C. Cook-Kallio, D. Parsons, A. Ngo, M. Perez, P. Hong, S. Pathak, H. Hosseini, S. Castelhano, and K. Yan; (third row) J. Wang, P. Herndon, L. Ritchie, A. Godhasara, D. Morrissey, P. Sheth, M. Khan, and O. Mahesri. (Courtesy Cheryl Cook-Kallio.)

Tommy Rancadore rides Rusty at his uncle's ranch near the drag strip around 1960. June 2005 saw the premiere of a television show called *Wildfire*, set in a little horse town in California called Fremont. Council member Bob Wieckowski, who grew up in Irvington in the 1970s, recalls "classmates who used to ride their horses on now-bustling Stevenson Boulevard." (Courtesy Connie Rancadore.)

The Irvington Farmers Market, located on Bay Street between Fremont and Washington Boulevards, opened in June 1994. Now year-round every Sunday morning and part of the "buy local" movement, it is one of the largest international food and produce markets in the Bay Area. For information on the Fremont/ Irvington Farmers Market, go to http://www.cafarmersmarkets.com. (Courtesy David Munn.)

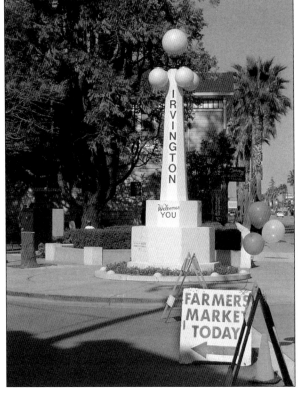